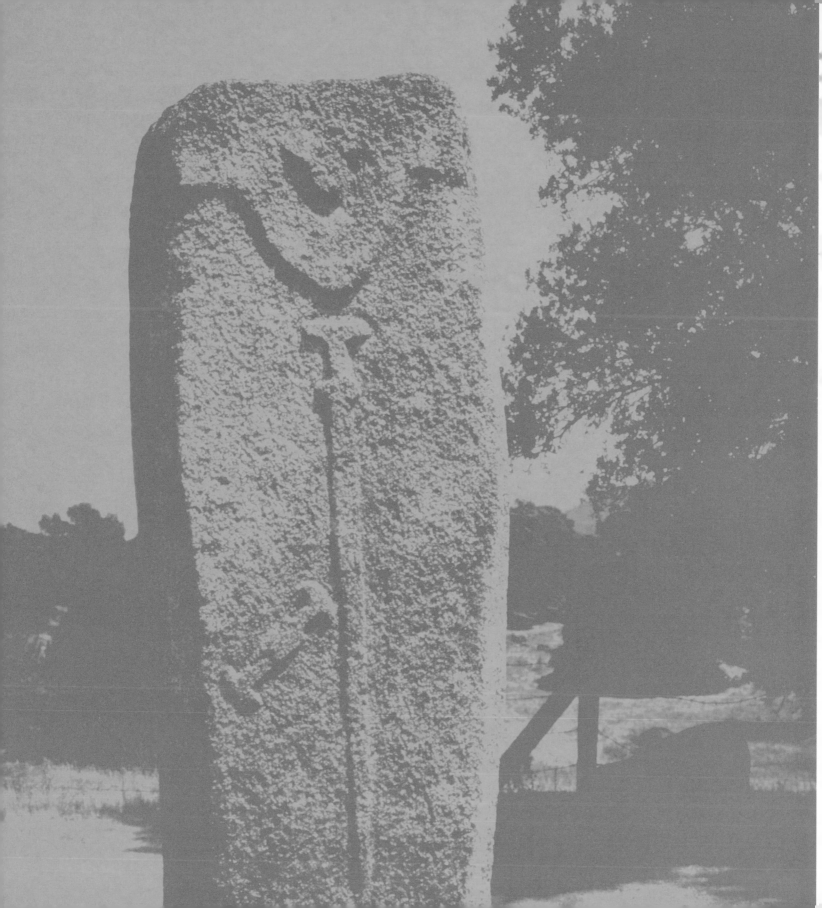

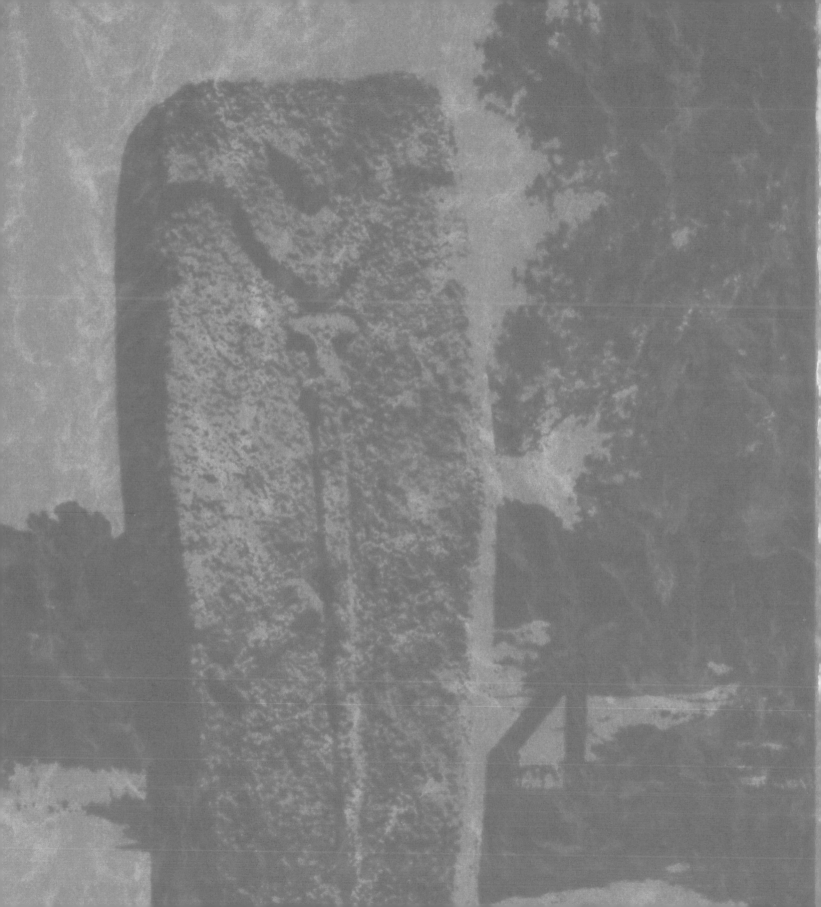

THE ART OF **THE CELTS**

LAUREL
GLEN

DAVID SANDISON

Published in the United States, 1998 by
Laurel Glen Publishing
5880 Oberlin Drive, Suite 400
San Diego, CA 92121-9653
1-800-284-3580

First published in 1998 by Hamlyn, an imprint of Reed
Consumer Books Limited,Michelin House, 81 Fulham Road,
London SW3 6RB and Auckland, Melbourne, Singapore, and
Toronto

Copyright ©1998
Reed International Books Limited

Library of Congress Cataloging-In-Publication Data
Sandison, David.
 The art of the Celts / David Sandison.
 p. cm.
 ISBN 1-57145-623-6
 1. Art, Celtic. I. Title.
 N5925.S26 1998
 704.03'916-dc21 98-18178
 CIP

Printed and bound in China

Publishing Director: Laura Bamford
Executive Editor: Mike Evans
Editor: Humaira Husain
Art Director: Keith Martin
Senior Designer: Geoff Borin
Design: Paul Webb
Production Controller: Julie Hadingham
Picture Research: Charlotte Deane

IRISH

NORTH SEA

BRITONS

GAULS

• La Tène

• Massalia

CELTIBERIANS

IBERIANS

MEDITERRANEAN SEA

Carthage •

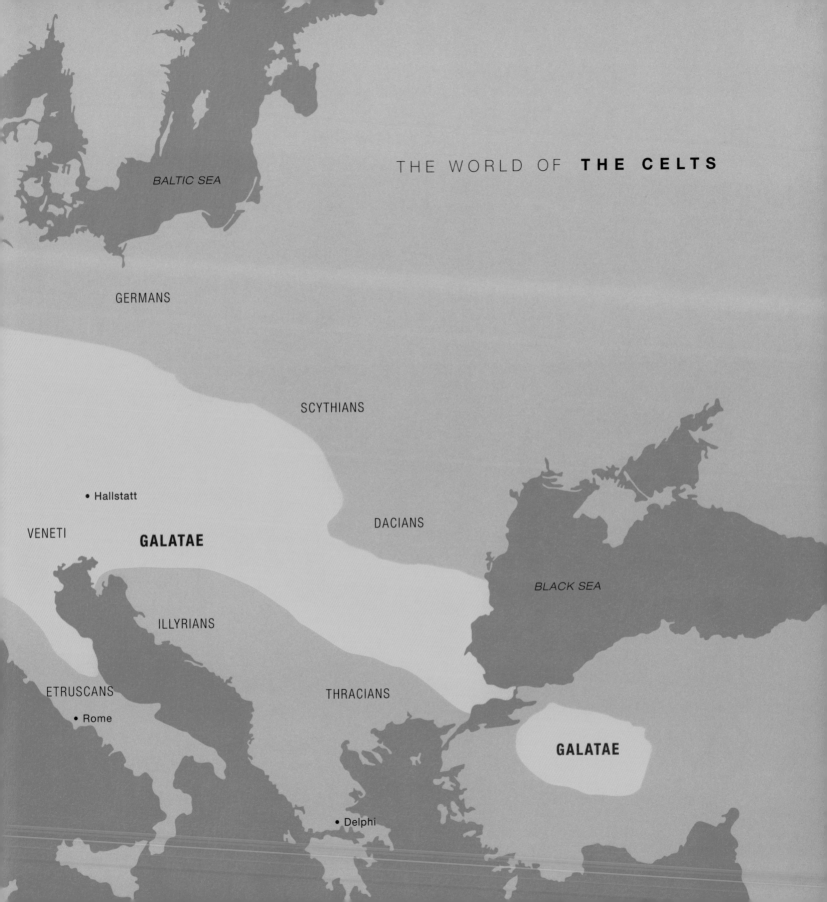

THE WORLD OF **THE CELTS**

BALTIC SEA

GERMANS

SCYTHIANS

• Hallstatt

VENETI **GALATAE**

DACIANS

BLACK SEA

ILLYRIANS

ETRUSCANS

• Rome

THRACIANS

GALATAE

• Delphi

7

INTRODUCTION

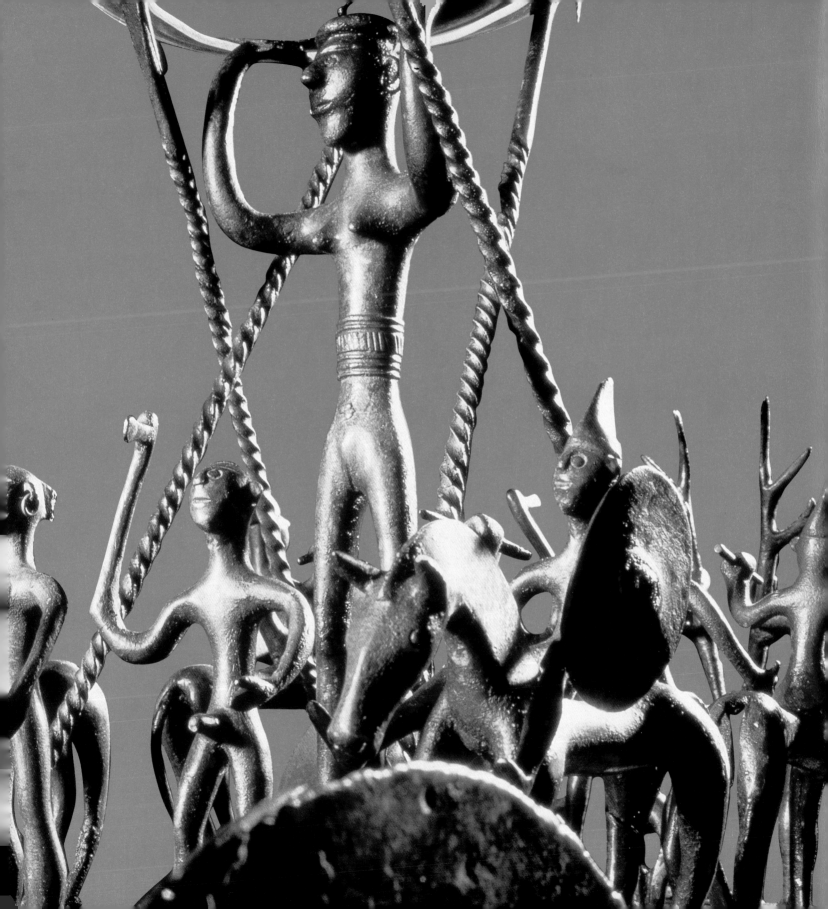

Most ancient societies reveal themselves best through their art, for it is from such evidence that we can glimpse the essence of their creators far better than by consulting almost any number of written records. Such documentation may give us the dates of notable events and the names of past leaders, heroes, and heroines, but they seldom offer us much information about the realities of those times or the lives of common folk.

◄ **Ritual bronze chariot** sculpture from the Hallstatt period, 7th century B.C.

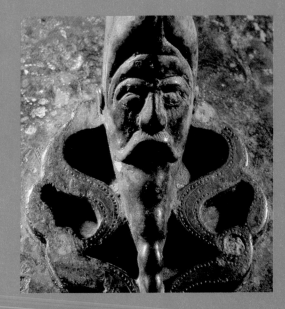

► **Bronze jug handle** in the form of a bearded head from the 5th–4th century B.C.

Investigating the Celts, the "family" of tribes that occupied and dominated vast swathes of Europe between 2000 B.C. and the 2nd century A.D., one is forced to rely almost entirely on the artistic evidence, for they did not write about themselves. The few references that do exist were penned by Greek and Roman historians and their accuracy can be questioned partly on the grounds that they were often written many hundreds of years after the events they describe, but mainly because victors are rarely the most objective or accurate of chroniclers.

However, it is from those sources that we can learn in general terms about the expansion and migration of the Celts (Keltoi to the Greeks, Celtae to the Romans) from their original central European locations in the 4th and 3rd centuries B.C. It was an expansion which eventually saw them established as far east as Asia Minor (in what is now central Turkey) and as far west as Britain and Ireland, their "empire" taking in Spain, France, Belgium, Germany, Switzerland, Italy, Greece, Austria, Hungary, and Romania in between.

While this book is intended to present various key facets of Celtic art through those millennia—concentrating mainly on the way they reflected and related to the societies the Celts created for themselves, their religious beliefs, class system, relationship with the world around them, their recreation, their skills as warriors, and their legacy as an artistic influence on the generations that followed—it is important that we devote some time explaining just who these people really were.

So much romantic nonsense surrounds the Celts, much of it historically inaccurate, it is best to restrict ourselves to the facts which have been gleaned from some 150 years of intense archaeological research. Given that no contemporary written records exist and shards of the Celtic languages survive

▶ **Tre'r Ceiri**, in Gwynedd, Wales, the Celtic fortress inhabited until the end of the Roman occupation in the 4th century A.D.

▼ **Bronze votive statuettes**, found in Gutenberg in Liechtenstein and dating from the 5th-4th century B.C.

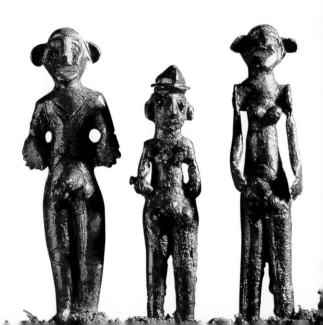

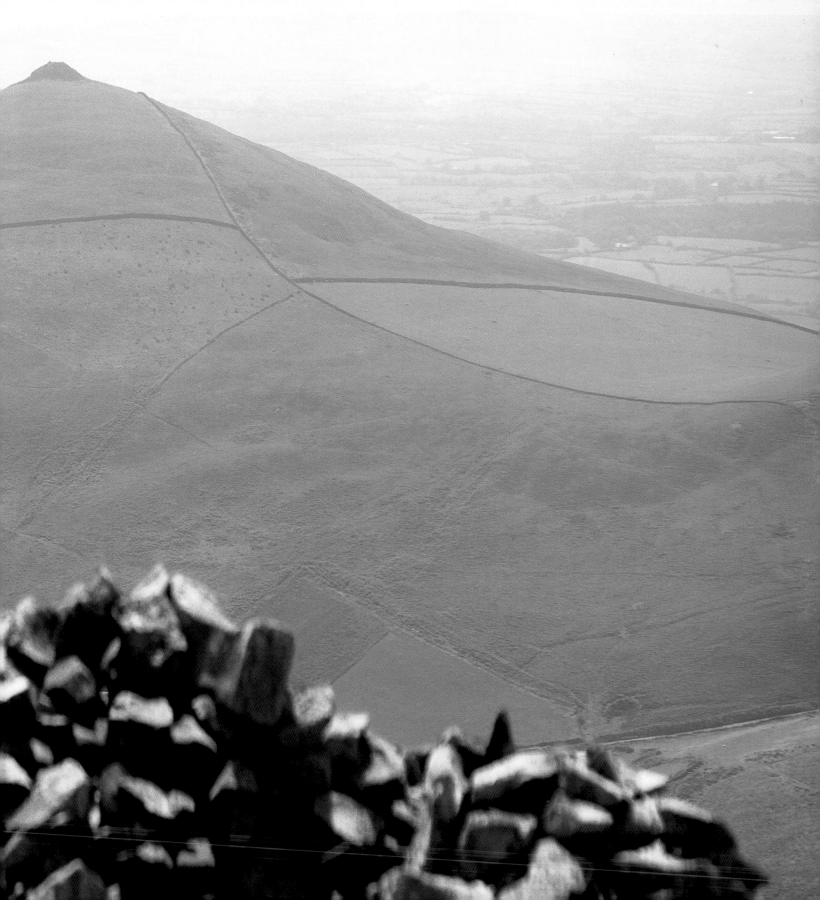

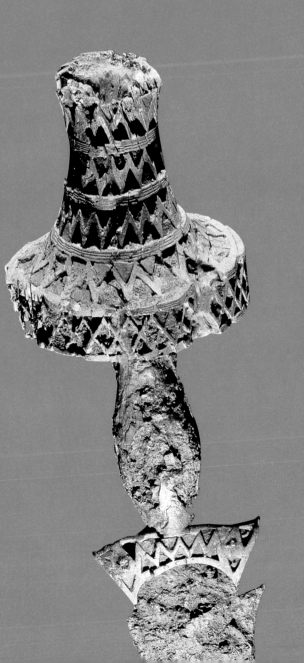

only in the native tongues of the Irish and highland Scottish, on the Isle of Man, in Wales, and Brittany—and then in an inevitably moderated and diluted form—archaeology and forensic science have played key roles in assembling this particular jigsaw, although disagreements are still common among experts in this field.

That said, it is generally accepted that the Celts were members of an early Indo-European people who migrated and settled across most of Europe between the 2nd millennium B.C. to the 1st century B.C. Some of the best archaeological evidence of their culture came initially from the countryside around Hallstatt, near Salzburg, Austria, where more than 2,000 graves discovered there during a 50-year investigation—which began in 1846—enabled scholars to apply dates to the development of Celtic society for the first time.

Most of the graves fell into two main periods, the earlier dating from the Bronze Age (about 1100 to 700 B.C.), and the later from the start of the Iron Age (around 800/700 B.C.) to 450 B.C. Near this vast burial site, there was also discovered a prehistoric salt mine in which tools, scraps of clothing, and miners' bodies lay preserved. So comprehensive was the data collected at Hallstatt that all subsequent finds which fell into the same time periods were categorized as Hallstatt A, B, C, or D.

◀ **Hilt of an iron sword**, ivory with rich amber inlay, found at Hallstatt in Austria, from the 7th century B.C.

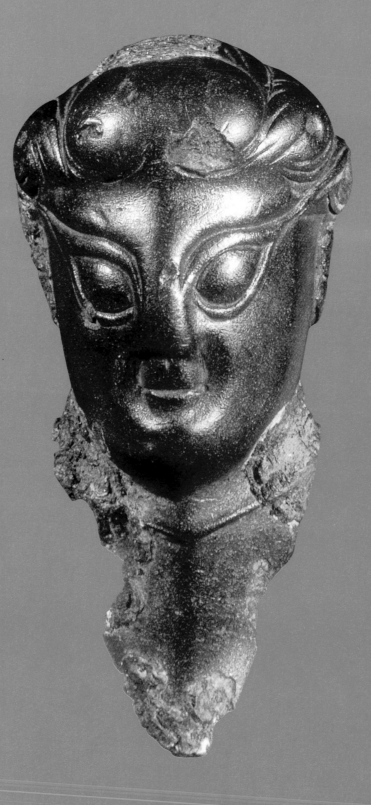

► **A female head** in bronze
from 5th-4th century B.C.
discovered in Stradonice
in the Czech Republic.

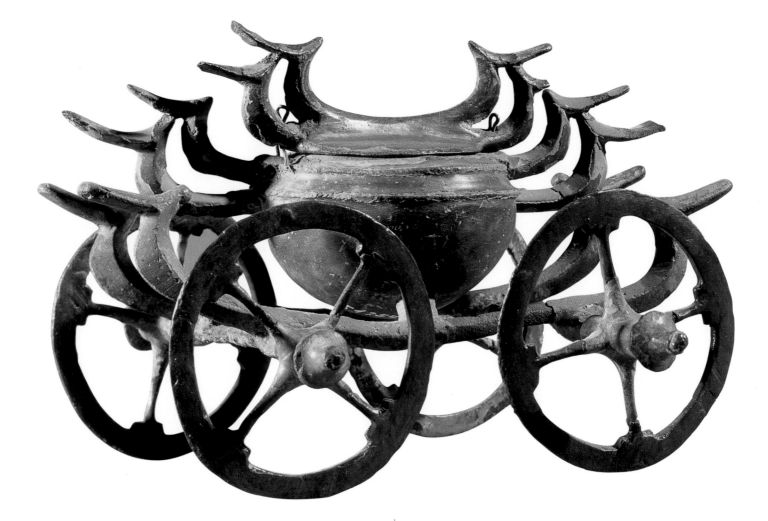

Found in Transylvania, a bronze model tank wagon with bird-shaped decorations. Dating from the 8th century B.C.

Briefly, in Phase A, the use of iron was rare, and the occupants of the flat graves (or under very low mounds) had all been cremated. Phase B, which was confined to the western regions, marked the return to domination in southwest Germany of the Old Bronze Age population and the subsequent re-emergence of the tumulus (or barrow) as the burial site for the cremated remains of their occupants.

Halstatt C saw iron coming into widespread use for weaponry, although bronze still featured heavily, both for swords (which featured scrolled chapes, the metal mounting at the upper end of the weapon), personal jewelry, and long girdle mounts. During this period both cremation and inhumation (interment) were practiced while pottery was both unpainted and polychrome.

While Phase D is not represented in the area around Hallstatt itself, it lasted elsewhere until the appearance of what is known as the La Tène period. Hallstatt D burials were mostly by inhumation and the pottery often fell short of the high standards achieved earlier, both in technique and style. Early Greek vessels were found in the western regions, while dagger-swords with antennae or "horseshoe" hilts, girdle mounts, and a variety of ring ornaments and brooches featured widely among the metal objects found.

In general, Hallstatt art was geometric in style, tending toward the extravagant. Although a widely used bird motif may be traced back to Greece, that region's "Oriental" influence is hardly found in early Celtic art. Plant patterns occur only rarely in those earlier periods, Celtic potters apparently aiming to create a strict symmetry of pattern in which arrangements of paired figures are characteristic. They were adept at breaking up smooth surfaces and using contrasting colors.

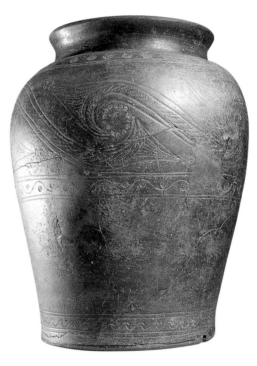

▲ **Ceramic cremation urn**, with an intertwined pattern made up of the letter S. From France, 4th century B.C.

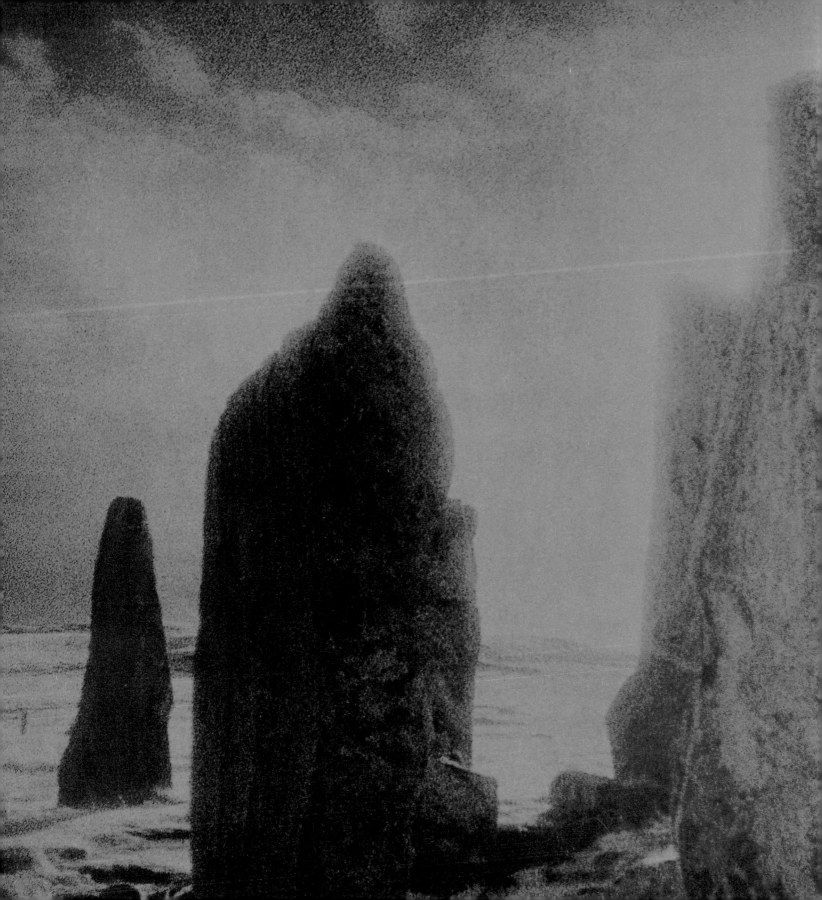

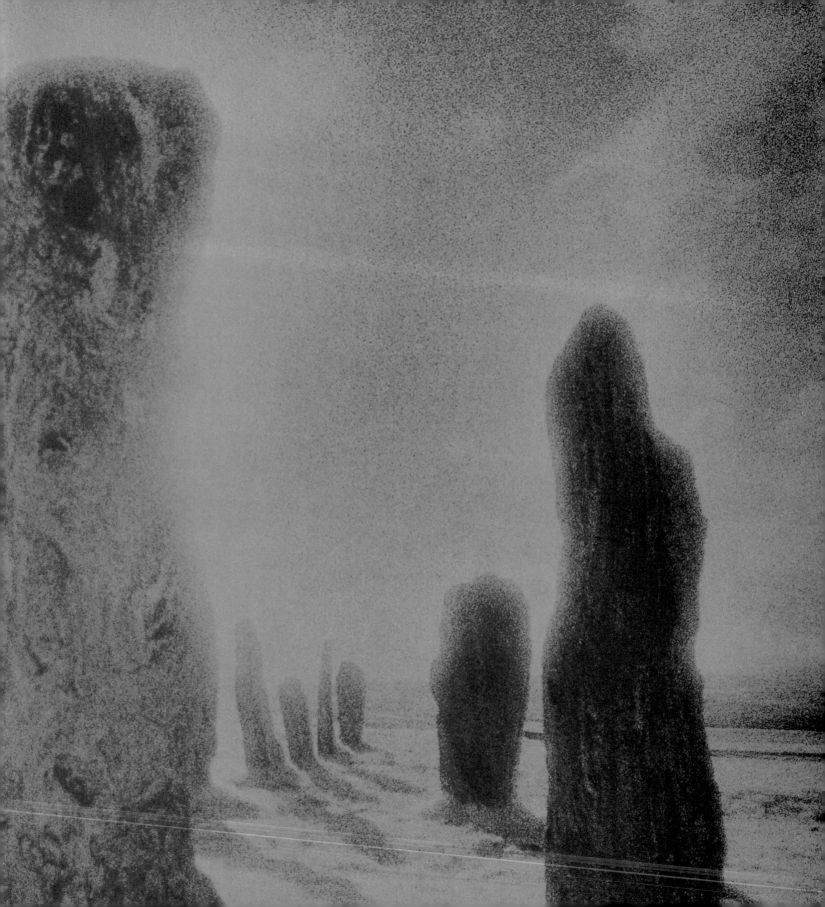

La Tène (in French, "the shallows") is the name given both
to the archaeological site at the eastern end of Lake
Neuchâtel, Switzerland, and to the Late Iron Age culture of
European Celts, roughly from the mid-5th century B.C.—when
the Celts are believed to have first become influenced by
Greek and Etruscan cultures—to the mid-1st century B.C.,
when pressure from German invaders and an ascendant
Roman empire signaled a decline in Celtic superiority.

This site was revealed in 1857 when the level of Lake
Neuchâtel dropped to reveal more than 3,000 metal objects
cast into the waters from which the remains of ancient wooden
bridges and staging now emerged. This new material culture
boasted distinctive armaments, including two-wheeled
chariots, and decorative art which traveled, with its makers
and owners, eastward into Romania and Hungary and north-
west to Britain and Ireland. In many ways, the La Tène culture
was the pinnacle of pre-Christian Celtic culture and creativity.

◄ **A ceramic cremation
urn**, (detail) found in the
burial mound of Lann-
Tinikei at Plomeur,
Morbihan in France.

During La Tène A (450-390 B.C., but all dates are inevitably approximate) the first Greco-Etruscan imports and influences were strong enough to create a new style in Celtic pottery design, characterized by spirals, circular patterns, and S-shapes. La Tène B (400-300 B.C.) witnessed even more diversity of influences as the Celts embarked on their greatest migrations. Among the features which remained popular and constant, however, were long iron swords, heavy knives, and lance-heads. During this period, burials were executed either by covering the body with stone heaps or flat burials in coffins.

La Tène C (300-100 B.C.) witnessed a greater mingling of the Celts and those they traded with or conquered, so creating a much wider variety in the decorations found in different regions of the Celtic empire. Iron swords now boasted intricately decorated scabbards and hilts, while other common artifacts included iron scissors and tongs, wooden shields with iron bosses, and heavy broad-bladed spearheads.

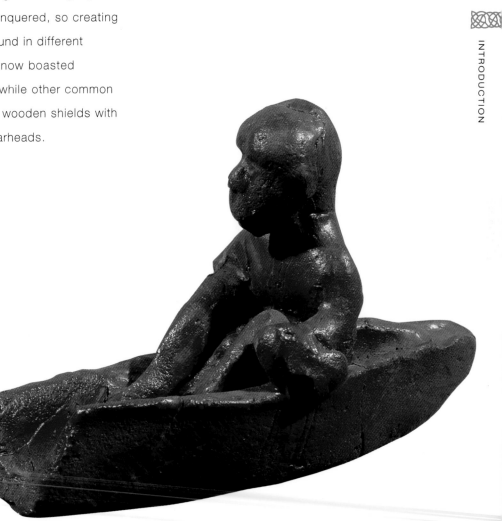

▶ **A votive clay model** boat with a separate (removable) oarsman which dates from the 1st century B.C., found in Magdalensberg, Austria.

It was during La Tène D (100-15 B.C.) that Celtic power and influence was all but completely obliterated by repeated Germanic invasions and the remorseless advance of Roman armies. The only regions to maintain a more or less undiluted Celtic heritage were those that were not settled by the Romans, of which Ireland and highland Scotland were the most notable. Elsewhere, the artifacts that have been unearthed—agricultural implements like scythes, saws, iron sickles, hammers, and ploughshares—are accepted to be the direct result of Roman occupation, while silver coinage, all of which was based on Roman and Greek templates, neverthe-less provided an invaluable source of our knowledge of Celtic personal names.

Apart from Hallstatt and Lake Neuchâtel, some of the most important archaeological sites in mainland Europe—in terms of the evidence they provided of the extent to which the Celts traded among themselves and with the outside world—are arguably those found in the Côte d'Or region of France, on and around Mont Lassois, near Châtillon-sur-Seine.

The hill-fort of Vix, situated on Mt. Lassois itself, is believed to have been the heart of political authority and trade during the 6th century B.C. Celtic, Greek, and Italian artifacts testify to extensive trade links between the Celts and the classical world, while the tumulus burial sites which scatter the area have provided a wealth of art to delight the senses and throw more light on the lifestyles of their noble occupants.

We cannot know whether the materials found in Celtic graves were created for purely ceremonial reasons, or whether they were the possessions their occupants used every day and elected to take into the next world. Perhaps that is less important than acknowledging that they invariably represent a

craftsmanship, skill, and sensitivity on the part of their creators that is the equal of any found during the same periods in the classical world.

There can also be no doubt that artists and craftsmen were very important figures in Celtic society, even if they do not—with the exception of some metalworkers and coin-makers—appear to have "signed" their work. With their own history an oral one, it would have been vital for someone to capture and represent the "soul" of the natural world, powerful and ever-present, and to create articles of great value and beauty for personal adornment and prestige, for worship and, crucially, for trade and battle.

While Celtic art's beginnings are generally accepted as coincidental with the earliest Hallstatt Iron Age culture, it must have had its genesis during the preceding Bronze Age. Celtic artists did not live in a cultural limbo, but absorbed, adopted, and adapted the traditions of others—the Italians, Greeks, Persians, Etruscans, Egyptians, and others in later times—to create something both entirely new and essentially Celtic.

More than almost any other element, art unifies the Celtic world. The same themes, patterns, and techniques tend to recur across that world, with changes in style being echoed many hundreds of miles away on or about the same time. In this way, Celtic art confirms the existence of a stratified, interlinked, and confident society.

Although most surviving Celtic artifacts are necessarily aris-tocratic, more humble examples have been found in the form of embellished domestic cooking and storage pots, and in brooches which appear to include inscriptions or messages possibly unique to their owners. While we can be reasonably certain that this art was used to confirm rank, status, and

◀ **A carved obelisk** from the 5th-4th century B.C. and one of the earliest examples of Celtic sculpture in stone.

relationships between people and groups in Celtic society, we can only guess whether there are direct references to pagan deities worked into their complex designs.

Arguments against this include the fact that, for most of the pre-Christian period at least, Celtic artists, like some of their Islamic and Judaic counterparts, shunned representations of their gods in human form, the human form itself, iconography, and naturalistic imagery. To do otherwise was taboo.

This, of course, changed dramatically in the early Christian period when figurative art dedicated to God and Christ became a valuable tool in spreading the word to largely illiterate congregations. Ornately carved crosses and illuminated manuscripts (of which more, later) helped celebrate and transmit the Christian message in dramatic fashion. The monks who painted those manuscripts not only drew on their Celtic past for artistic inspiration but continued their legacies of immense skill and an innate love of form, design, color, and beauty.

If proof is required of the importance of artists and craftsmen in Celtic society, it can be found in the fact that metalworkers are known to have traveled with troops from one battle to another. This cannot be simply explained away as an expedient method of ensuring running repairs to arms and armory, for the craftsmanship applied to each item was both unique and often extraordinarily ornate.

There is also a strong body of evidence to suggest that, by the 4th and 3rd centuries B.C., Celtic communities were not only served by resident artists who worked for one particular patron, but that itinerant craftspeople—all of them following traditional manufacturing methods and artistic motifs—were traveling abroad across Britain and Europe. And later, Celtic

A bronze appliqued decoration in the form of a horse and rider. Germany, 5th century B.C.

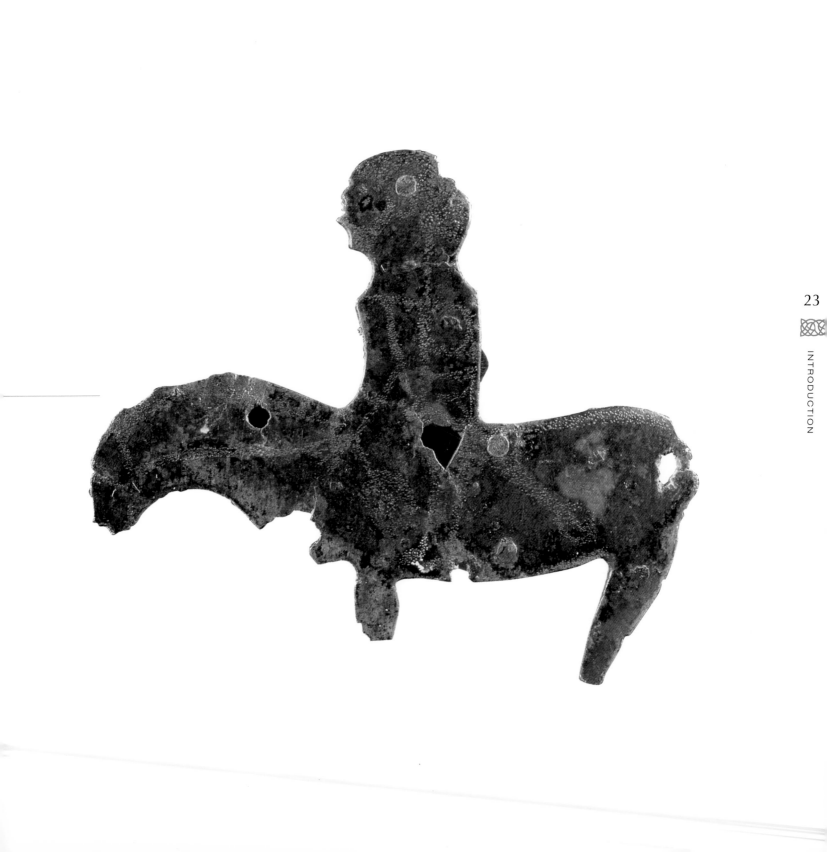

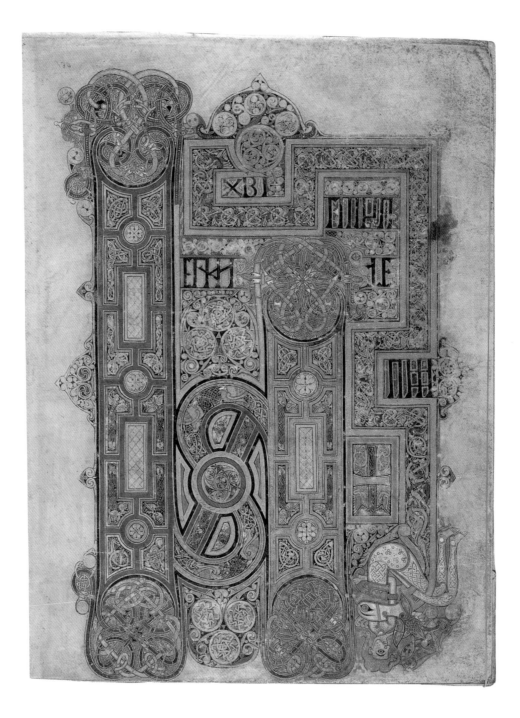

artists appear to have readily applied their skills in the service of their Roman masters.

Celtic art was a fluid, moving, and ever-changing discipline, and its practitioners were never averse to adapting elements of foreign art they found pleasing. Thus, later classical influences came to be an intrinsic part of Celtic designs, modified in subtle ways but recognizable nonetheless.

The Celts may have been barbaric and brutally ferocious in battle, as Greek and Roman commentators claimed in an invariably dismissive fashion, but they lived in barbarous times when no quarter was expected or given. As we shall see, they were also an inventive, gifted, and clever people. That they were able to create works of such great beauty is testament to a deep inspirational spirit and humanity which still calls to us thousands of years later.

◄ **An illuminated page** from the *Book of Kells* bearing the ornate initial of the St.Mark's Gospel (8th century A.D.).

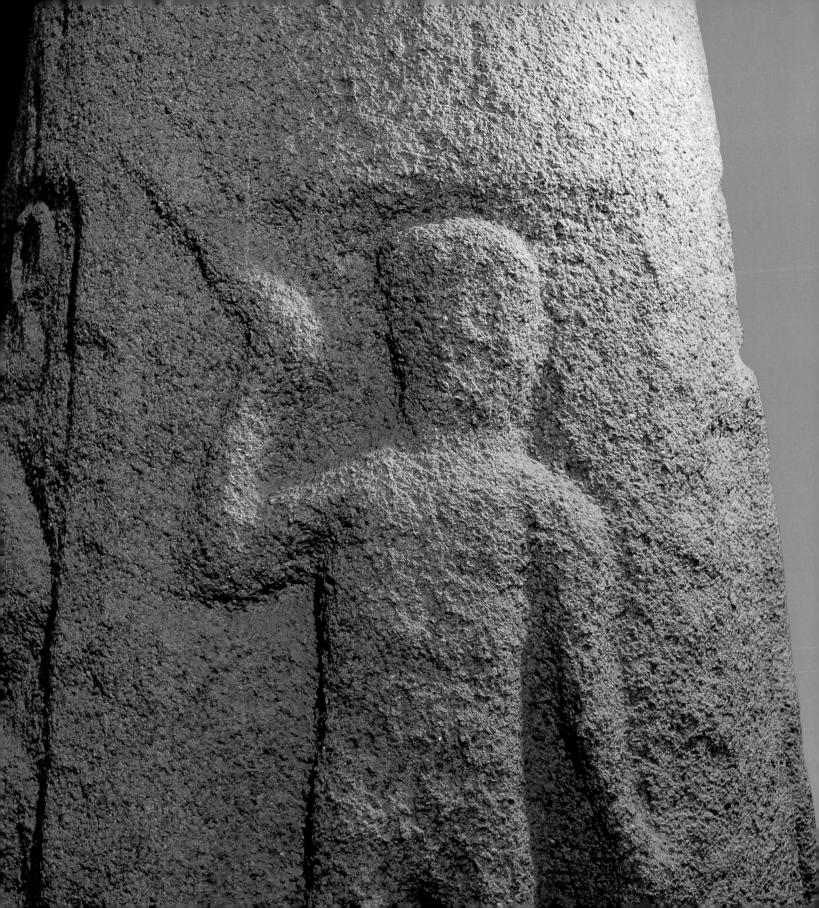

In common with other aspects of Celtic society, much of what we know about their religion is derived from two principal sources—the writings of Greeks and Romans such as Poseidonius, Lucan, Diodorus Siculus, Strabo, and Julius Caesar, and the many Irish, Breton, and Welsh myths and sagas collected and recorded by Christian monks centuries later.

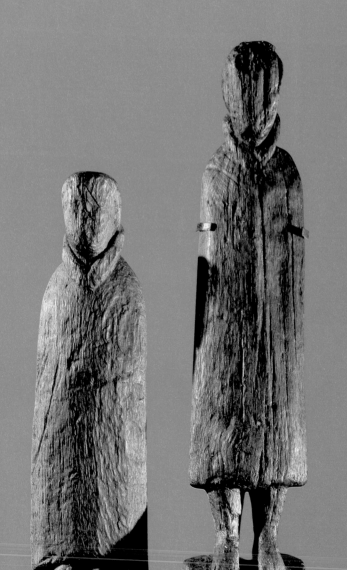

◀ **Standing stone of Kervadel** (detail), found in France. Hercules, Mars, and Mercury can be identified among the carved decoration.

▶ **Three wooden statuettes**—votive offerings of 1st century A.D. Roman-Gallic origin, unearthed at a cult site at the source of the River Seine in France.

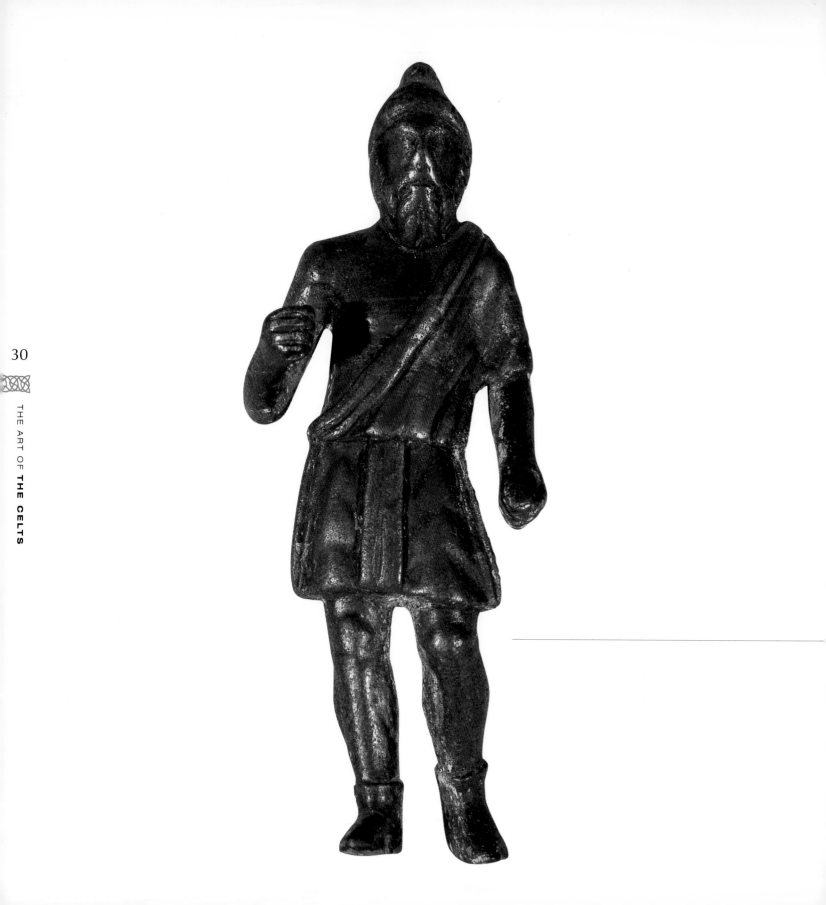

Inevitably, the myths are largely a jumble of remnants which are difficult to assemble satisfactorily. The Romans went to some lengths to give their own gods' names and roles to the Celtic deities which most closely matched them, as did the Greeks and the Germanic tribes who overran traditional Celtic strongholds. The Romans also did much to begin eliminating the old gods when they stripped the druids—those charged with maintaining Celtic oral traditions—of their power base.

Although a shared Indo-European heritage showed itself in some parallels between the two cultures, Roman state religion—for the most part impersonal and strictly formal—in fact had very little in common with Celtic theology which was mostly dominated by a spirit of animism, a belief in supernatural powers which organized the material universe, and a dream-like consciousness.

Prominent among the male Celtic deities, Caesar learned and noted, was the god Lugus (or Lug), most commonly represented by artists with a sun symbol. It was simple for the Romans to associate him with their own Mercury, just as the Greeks superimposed their sun god, Apollo, with whom Lugus also shared the patronship of music and mastery of crafts.

Almost as important as Lugus was Cernunnos, the stag-horned Lord of the Animals. Stags loom large in Celtic literature, embodying the attributes of the shaman, or priest, in communication with the gods.

Divine significance was also accorded many other animals, including the bull, boar, crane, and raven.

One of the most powerful female deities was a mare goddess—variously named Rhiannon (in Britain), Macha (Ireland) or Epona (Gaul)—who shared, along with the crow-goddess and "Great Queen," Morrígan, responsibility for the

Bronze figurine of Celtic Smith God (Sunderland, UK) 2nd-3rd century A.D.

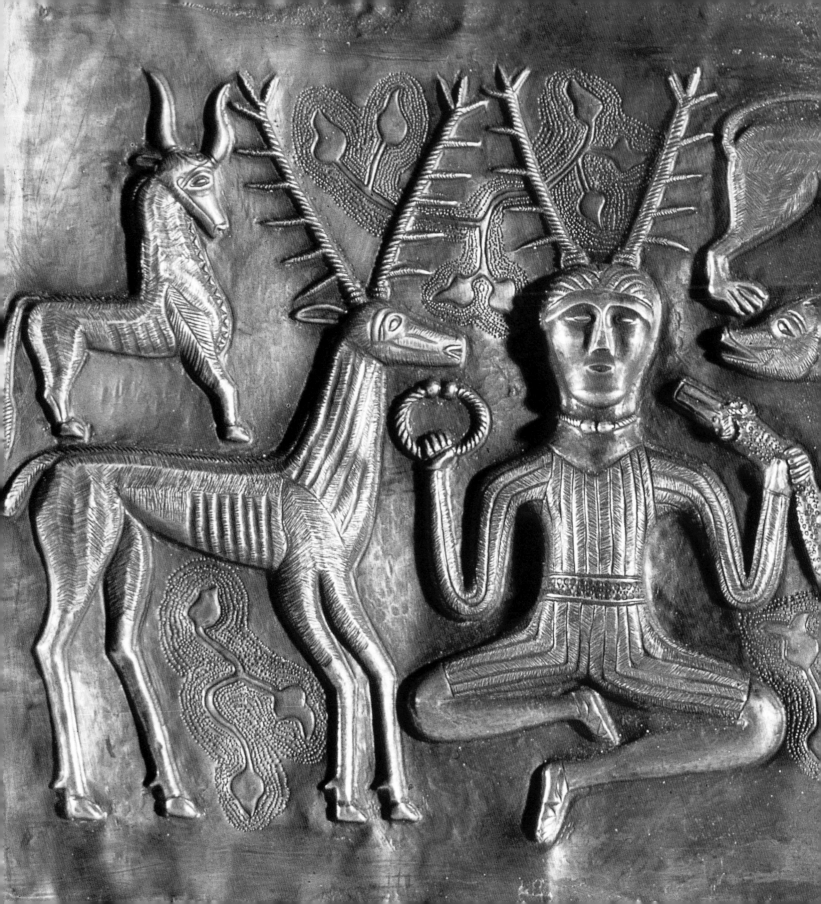

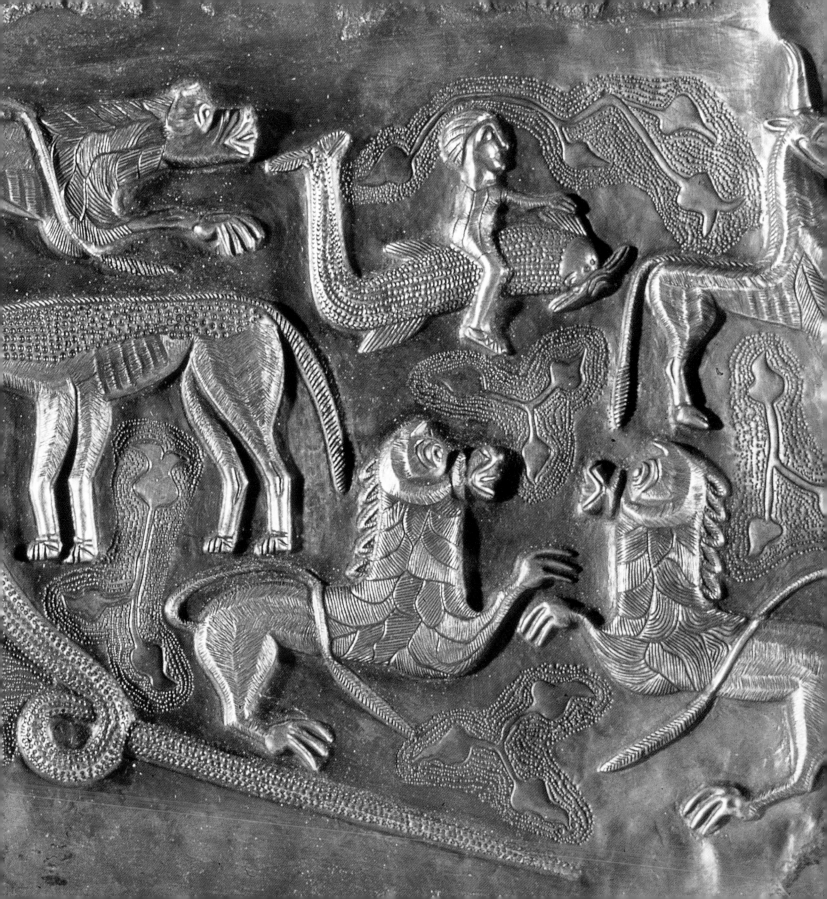

◀ **Previous page**, relief plate on the Gundestrup cauldron which shows the stag god Cernunnos with choker and snake amidst various animals.

▼ **The head of** a female deity, probably the Celtic goddess Brigit, inspired by the Roman goddess Minerva.

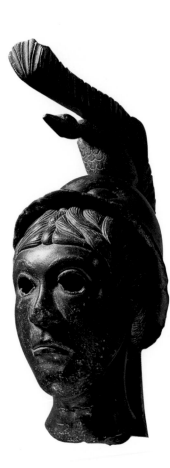

fortunes of king and tribe. The former personified fertility while Morrígan governed the areas of death and rebirth.

Like many goddesses who manifested themselves in groups of three, or in triple aspects, Morrígan was held to represent death-prophecy, battle panic, and death in battle. Examples of the group of three include the Irish Brigits, who ruled over healing, poetry, and metalcraft, and the Gallic Matronae, or three mothers. The Gauls, too, worshiped a triple god whose aspects comprised war, thunder, and a bull spirit, which may have represented fertility, and to whom they also offered human sacrifices.

Celtic religion was centered on the relationship and inter-play of a divine element—what they called "the otherworld"—with the land and waters. Guardian spirits, invari-ably female, were believed to dwell in springs, rivers, wells, and hills, many of which still survive as place names. The ocean—a force of strong magic and mystery in surviving British and Irish mythology—was ruled by the god Manannán, while the earth itself was regarded as female.

Intriguingly, there are strong links with the Greek legends of Atlantis and the Celtic "otherworld," which was depicted as a group of islands far away in, or sometimes under, the Western ocean. Their perpetually young inhabitants lived a life that was

▶ **A Celtic deity,** bronze head of a statue with enameled eyes dated 3rd century A.D., unearthed in France.

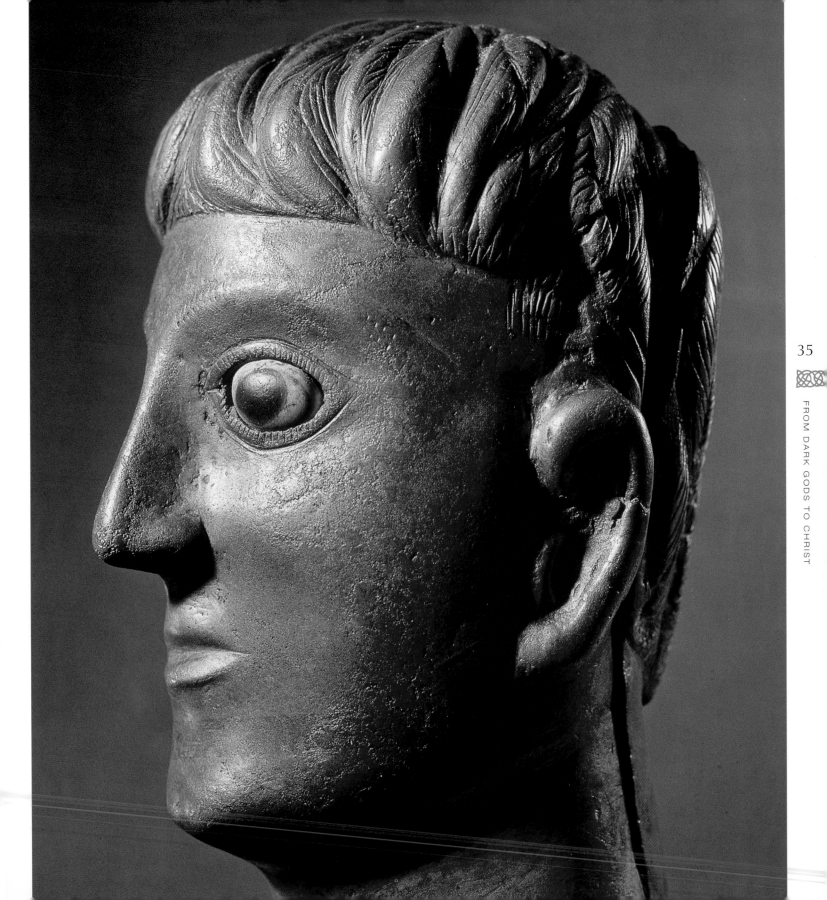

dedicated to feasting, music, and competitive combat, while "otherworld" females lured away many a hero of Irish sagas just as, later, Christian saints were reputed to have sailed off to find them.

Shape-shifting and magical links between humans and animals played a great part in Celtic cosmology, while the surviving myths indicate a strong belief in reincarnation and the transmigration of souls—an echo of the same beliefs we know existed in other prehistoric societies with whom the Celts boasted cultural links. Later Celtic poetry reflected an abiding fascination with animal consciousness and transformations well into the Christian period.

Trees played a central role in Celtic ritual, as is evidenced by such artifacts as the so-called Paris Relief (the work of the Parisii, Gallic inhabitants of the region in which the modern French capital was established) and the Gundestrup Cauldron (a Danish 1st century B.C. silver ritual vessel) both of which show scenes of woodland ritual. Several types of wood were regarded as having prophetic properties. Indeed, the druids themselves took their name from an ancient Indo-European word which means "Knowing (or Finding) the Oak Tree," while the letters of the Celtic alphabet and the names of months were based on tree-symbols.

Irish cult life—the one we know best—revolved around seasonal observances, and there is no reason to believe that this was unique in the Celtic world. The two most important festivals were Beltine, or Bel's-Fire (celebrated on May 1, and held in tribute to the god Belenus, his province over war and other pursuits such as crop planting, hunting, and courtship) and Samain, the November 1 festival which marked summer's end, or the Feast of the Dead.

▶ **Severed head of a man** held by a hand, a sculpture from 3rd-2nd century B.C.

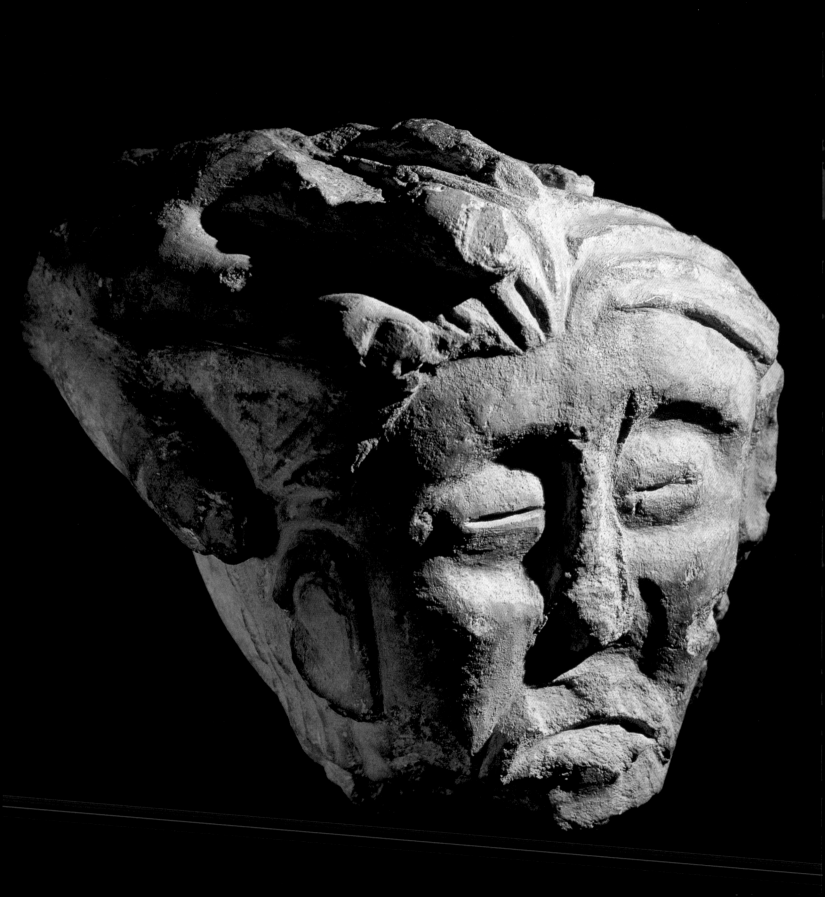

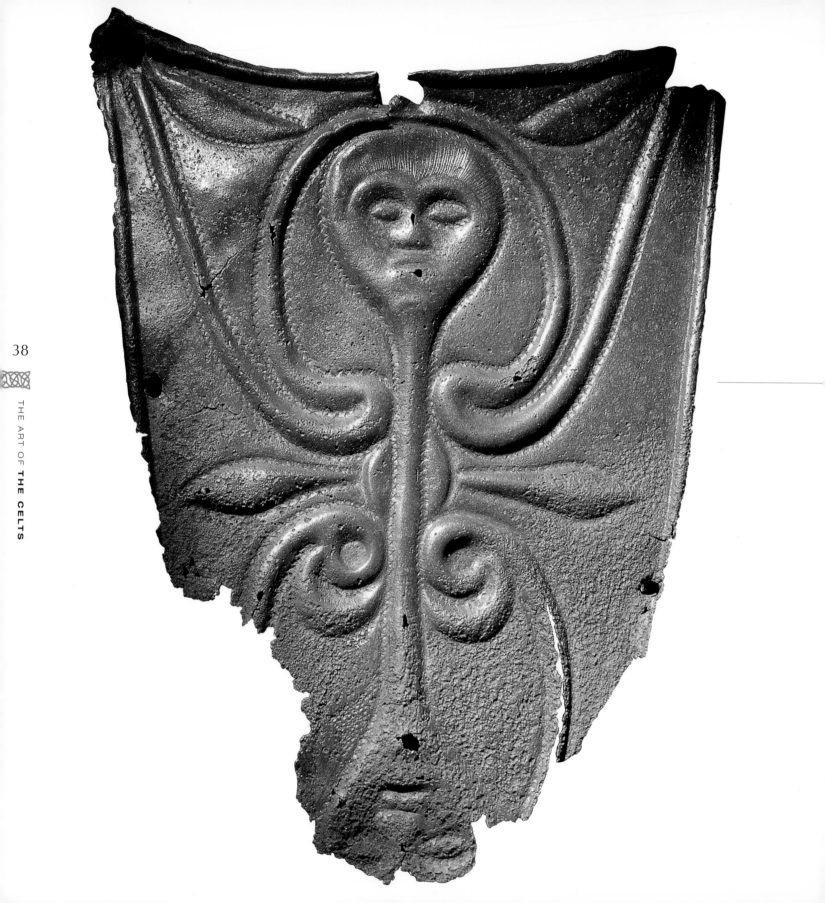

Along with other lesser festivals such as Imbolc (February 1 to celebrate the start of spring, sacred in Ireland to the goddess Brigid) and Lugnasad (the August 1 feast and harvest fair to mark the marriage of Lugus), these were easily adopted to create the new Christian calendar, while many traditional Celtic places of worship simply provided the foundations for a Christian church or monastery. And so the dark gods gave way to Christ, himself one part of an all-powerful and indivisible trinity (Father, Son, and Holy Spirit), a concept the Celts would surely have had little problem accepting.

One of a pair of copper ornamental fittings, possibly from a shield. Wales, 1st century A.D.

It is no surprise to learn that triplism—the merging of three elements to create one whole, the number three having an especial sacred and magical symbolism—is prominent in Celtic art. As early as the 5th century B.C. triskeles appear in a variety of locations. A three-armed whirligig motif, the triskele would remain a constant decoration all across the Celtic world, on helmets, stone carvings, jewelry, and other items, until Christian times, when it was retained to form a recurring part of the illuminations for Anglo-Irish manuscripts such as *The Book of Kells,* the *Lindisfarne Gospels* and the *Book of Durrow.*

▶ **Two heads**, joined at the back of the head; a stone sculpture from France, 4th-3rd century B.C.

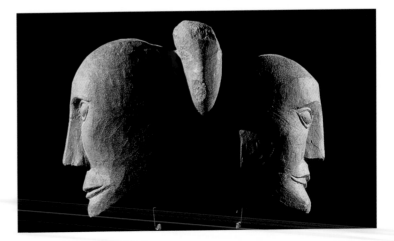

▶ **Silver phalera** from a
horse's harness with
male heads as rim
decorations and a
triskele central motif.
From Italy, 3rd to 1st
century B.C.

▼ **The Kermeria Stone**,
with a clearly visible
swastika motif, from
the 4th century B.C.

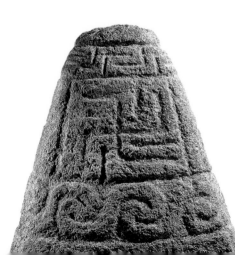

Also ubiquitous as a motif throughout the Celtic period—
and used, like the whirligig, to conceptualize the rotation of
both the sun and the seasons—was the swastika, or crooked
cross, an ancient Indo-European solar image which survives to
this day in Hindu and Buddhist tradition as a symbol of good
luck. In Romano-Celtic Europe the swastika was associated
with a sun god cult. It is not too fanciful to suggest that both
the swastika and triskele may have been powerful talismatic
emblems which were meant to endow magical protection on
the objects which they adorned and, just as importantly,
on their owners.

The Celts almost completely avoided representing their
gods in human form. Where examples of religious depiction are
found, only the head of the deity is shown. The widespread
use of double (janiform, after the two-headed Roman god,
Janus) or triple-headed (triadic) imagery is widely accepted as
reference to the supernormal or supernatural. When humans
are depicted, their bodies are stiff, almost archetypal, while
faces are invariably inscrutable and mask-like.

Given the wealth of evidence that exists concerning the
Celts' all-consuming fascination with the natural world, the
spirits who inhabited it, and the powers they possessed, it is
also not surprising to know that Celtic artists drew extensively
for inspiration on what must have been, for them, a highly
sacred landscape.

While they portrayed aspects of the countryside in which
they lived—including recognizable European flora and
fauna—they also featured exotic and mythical elements to help
create their vibrant motifs. Thus, while the trees and foliage of
temperate zone Europe were included in their later work, so
were vines and other plants such as lotus flowers and

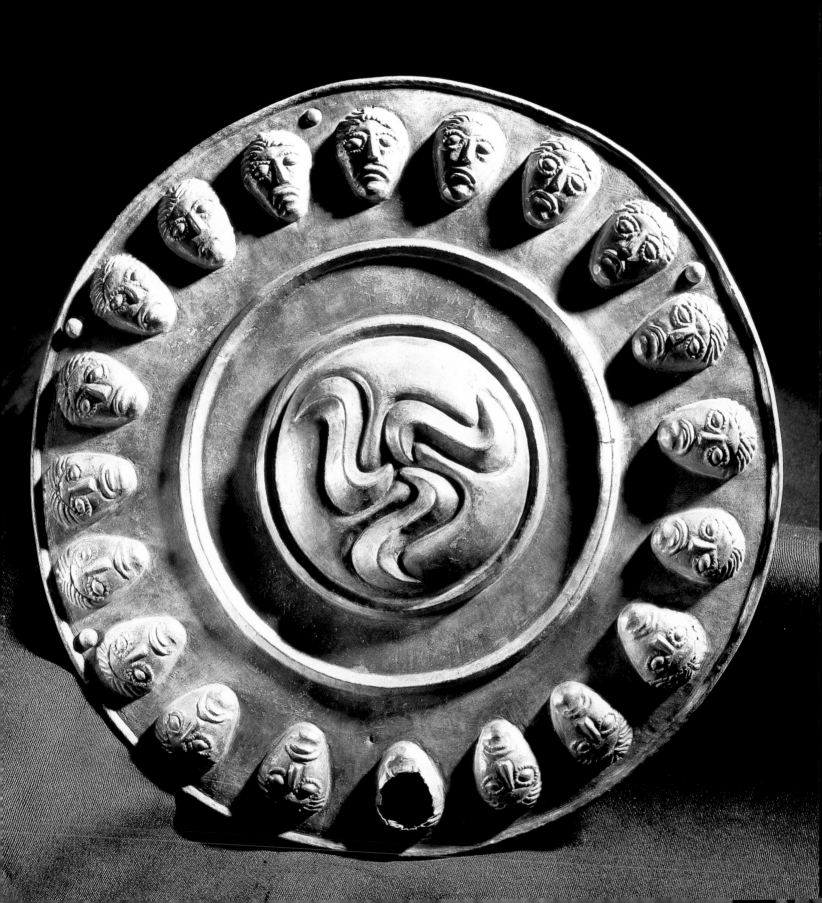

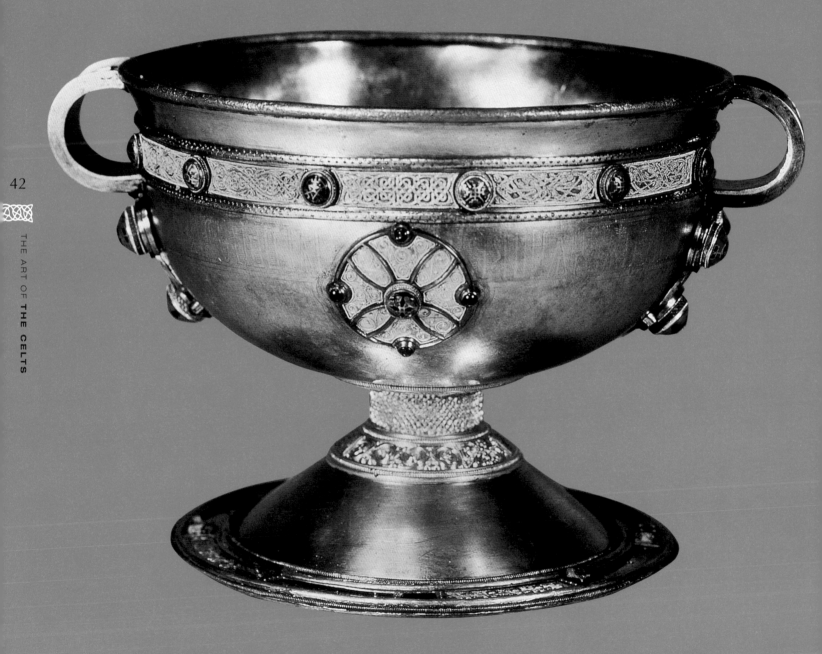

42

THE ART OF **THE CELTS**

acanthus, which belonged to more distant parts. Similarly, native beasts like wolves, horses, cattle, and boars jostled for space in their ornate carvings and moldings with exotic creatures like elephants and leopards, mythical sphinxes, and the eagle-headed, lion-bodied gryphon.

What was true of Celtic avoidance of the naturalistic representation of humans was equally so where animals and plants were concerned. Animals often become distorted into fantastic monsters, while plants—although clearly inspired by "real" flowers, leaves, and tendrils—were worked into elaborate fantastical patterns which weaved themselves across the surface they occupied, whether it be mirror, stone, or brooch, often resolving vertiginously into spirals or triskeles.

The results may have been somewhat abstract, tense, and asymmetrical, but those elements conspire and combine to enhance the impact and potency of the images. There is a small body of evidence to suggest that some Celtic artists may have used hallucinogenic drugs to heighten their imaginations and perceptions. Certainly, cannabis was found in one Hallstatt prince's tomb (at Eberdingen-Hochdorf, in Germany), while traces of other mind-altering substances have been identified in Iron Age bodies disinterred from bogs.

There is little doubt, however, that some Celtic motifs took their early inspiration—during the 5th and 4th centuries B.C.—from the Oriental and Mediterranean regions, probably via objects decorated with exotic images the Celts either merely considered highly attractive or found some resonance with and relevance to their own beliefs. Principal among these was the palmette, an Etruscan design which was itself based on the Oriental Tree of Life, a central stem with a number of lobes which unite to create a stylized tree or fan-like shape.

◄ **The Ardagh Chalice,**
from Ireland c. A.D. 700,
possibly the finest piece
of ornamental metalwork
from Celtic Europe.

Like the treskele and swastika, the palmette would become a universal Celtic symbol. Although it does appear on its own, often it is as part of a frieze (when it is most associated with lotus or lyre motifs and even human faces), the palmette was also used extensively to decorate items as separate as the elaborate and exquisite 4th century B.C. helmet unearthed in Agris, France, and the bronze plaque dating from the 1st century A.D. which was found in Tal-y-Llyn, Wales, its surface worked with images of human faces enclosed by palmettes.

It does not take a giant leap of logic to connect the Celts' belief in the symbolic and regenerative powers of trees with their reasons for adopting the palmette as a central motif for so much work over such a long period of time.

A belief in and fascination with shape-shifting found its way into Celtic art in many subtle ways, and it is not unusual for one to imagine (or realize) with a start that the image of a face has suddenly resolved in a mass of swirling foliage, only to vanish again when examined more closely. Then, just as one admits defeat, it can reappear. Whether this is the result of an artist's genius, or a trick of one's over-fertile imagination, it is impossible to say.

Similarly, Celtic artists were adept at creating clever, more obvious, visual puns in the form of double-image faces which, when inverted, reveal another—often opposite—aspect of the same character. Duality of personality was thus captured as art. Although we have no way of knowing whether such devices were intended to represent a specific individual, it is tempting to look on them as an early form of satire.

Celtic art and society were transformed by Christianity, and nowhere more so than in Ireland which, while other parts of Celtic Europe were colonized by new ascendant powers, had

▶ **The Ardboe Cross**, the 10th century Celtic cross to be found in Ardboe, County Tyrone in Northern Ireland.

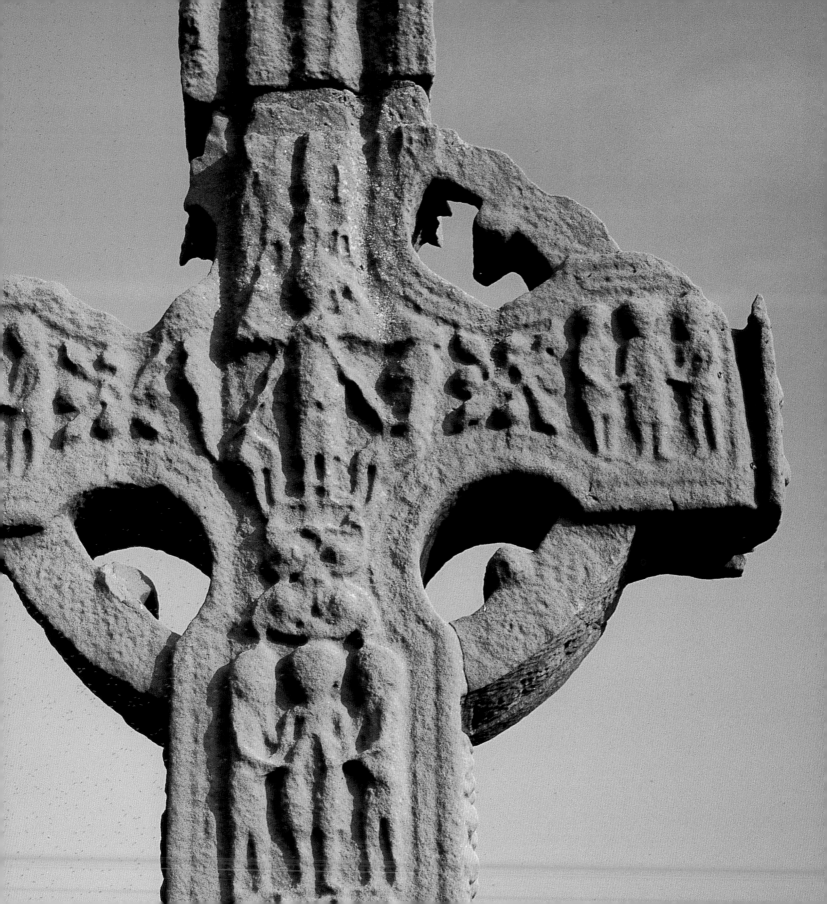

survived as a more or less "pure" culture after the collapse of the Roman empire. The Franks had invaded and conquered Roman Gaul, for instance, while most of Britain fell under the rule of the Germanic Anglo-Saxons.

Although Christianity had arrived in southern Britain during the latter stages of the Roman occupation (only to be largely eradicated by the Anglo-Saxons and then revived by the arrival of St. Augustine from Rome in A.D. 597), Irish Celts had been able to hold to their traditional ways—and this included their dark gods—simply because they had never been governed by Roman masters. The arrival in Ireland of Patrick, the Cumbrian-born Romano-British missionary bishop, in A.D. 432 soon opened the way for a transformation of the island and its assumption of a position at the very forefront of Celtic Christianity.

The missionaries and monks who converted Ireland to Christ were able to draw on vast reservoirs of native talent to create new religious art, including church plate, iconographic images, brooches, and other jewelry, chalices, ceremonial vessels, or illuminated manuscripts. Smiths who were capable of fashioning exquisite objects from bronze, iron, gold, and precious stones were ready and willing to devote their skills to such work, as ever absorbing new and foreign motifs and artistic styles to lay alongside echoes of their own heritage and mark the beginning of a great and immensely rich period of symbiosis and cross-fertilization between Ireland, Britain, and the rest of Europe.

◄ **A standing stone** with relief carving, 4th century B.C., Sainte-Anne en Tregastel, Cotes-du-Nord, France.

▼ **The Drumcliff High Cross**, an example of a 10th century Celtic high cross in Drumcliff, County Sligo, Ireland.

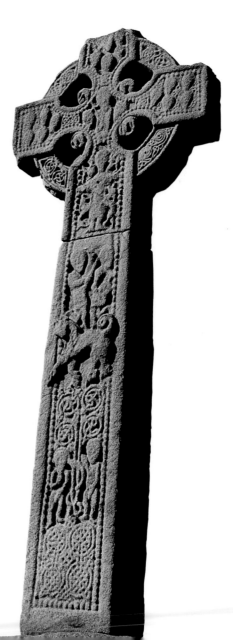

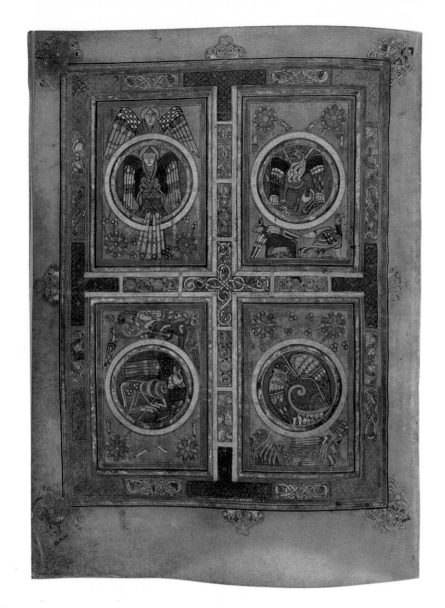

◄ **Symbols of the Evangelist** Apostles from the *Book of Kells*, 8th century A.D.

A page bearing ornate symbols of the Evangelists—the <u>Book of Kells</u>, housed at Trinity College, Dublin.

VERO

...nerbum in... apud dm̄
et ds̄. erat ucrbum hoc
erat inprincipio apud dm̄
Omnia pipsum pci sūt
sme illo fcm̄ est nihil..
fcm̄ est inippo uita erat... in
...uita... lux hominum
et lux in tenebris lucet...
...nebut...

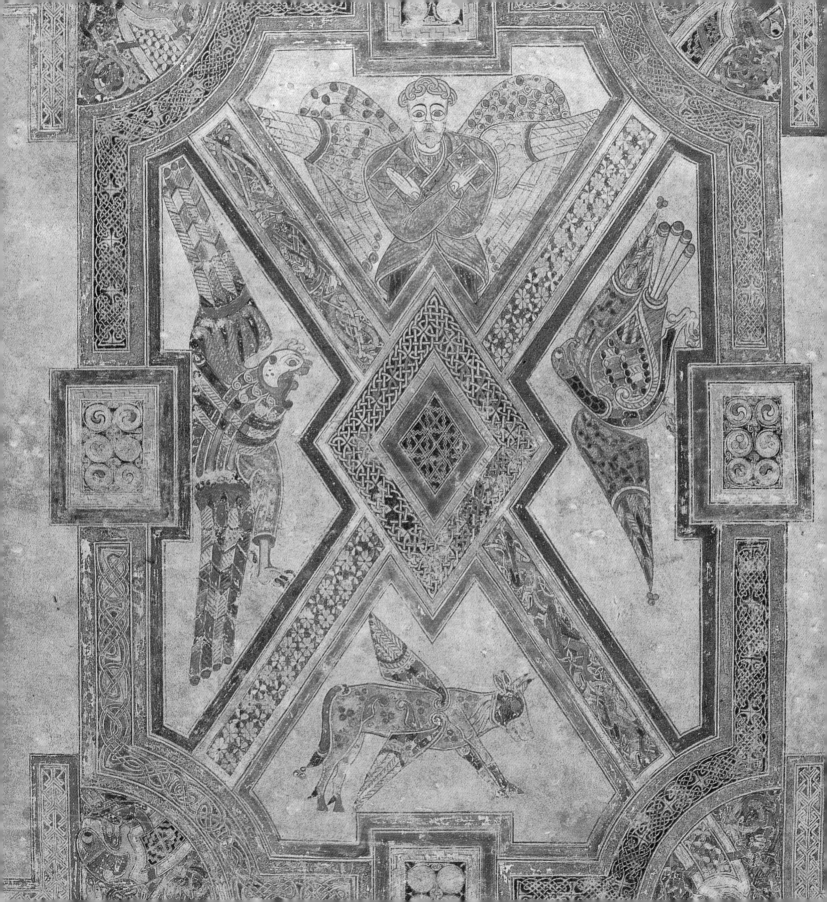

Those echoes of heritage, especially with the use of mean-dering complex spirals, triskeles, illusion, visual ambiguity, and fantastical animals, ensured the survival of Celtic tradition in early Christian art. This was also true of the thousands of Christian crosses that appeared across the Irish landscape and traveled to Wales, Cornwall, and Brittany.

While they—and the metalwork and manuscripts—of Christian Celts now bore the distinctive imprint of Mediterranean and Germanic artistic influences, many retained the motifs and designs once employed in the celebration of pagan gods. It is no accident that the principal feature of the so-called Celtic cross is the wheel or circle which frames the upper part of the figure. More than anything else, it puts one in mind of the solar image once used to denote the power of Lugus, although the Christian hierarchy was apparently prepared to interpret it as a victory wreath, proof perhaps of Christ's defeat of death itself through his resurrection.

While that remains the subject of debate, you may expect that there would be little doubt that the most outstanding examples of Celtic Christian art (and certainly the most famous) are the various illuminated Gospel books of the 7th-10th centuries A.D. However, you would be wrong, for there are some scholars who contend that the blend of Celtic and Anglo-Saxon features which most British and Irish Gospels combine so seamlessly, make them what they prefer to call "Hiberno-Saxon." This was because they were created in a time when the "real" Celts had been all but absorbed into the European mainstream.

In this writer's opinion that argument is mere pedantry, for the overwhelming artistic influence to be found in these early Gospels is Celtic. It is present in the repeated use of such

► **Book of Kells:** an illuminated page bearing an ornate initial "L," with intricate details including angels, cats, and fish.

traditional Celtic motifs as triskeles and spirals, the resolute avoidance of copying images from real life, and the continued inclusion of sinuous, distorted animal symbols and elusive human heads. The magical dream-world of Celtic myth and legend lives on in these books, even though the monks who painted them were Christians employed in creating Christian literature for a now-Christian society.

Nowhere is this more marked, perhaps, than in the highly illustrated pages of *The Book of Kells,* the manuscript begun at the monastery on the Scottish island of Iona in the latter part of the 8th century A.D. and completed, it is thought, almost a century later at the monastic community in Kells, County Meath, Ireland.

The more than 40 full-page illustrations (some of which were not, it must be said, painted by top-flight talents, while others remain in an unfinished state) and 2,000 illuminated capital letters in *The Book of Kells* are a stunning fusion of artistic traditions – Frankish (Merovingian), Mediterranean, and Coptic (Egyptian Christian) included. It is all in the detail, where one can easily find all the motifs so characteristic of La Tène period Celtic art—palmettes, triskeles, animals, mythical monsters, and scrolls included.

Early Christian art, fashioned by painters, metalworkers, and stonemasons, represents nothing so much as the union of a great artistic pagan tradition with the desire to celebrate a new creed with a flood of fresh creativity which could capture and reflect all their love and reverence.

The continued fascination we have for patterns and designs first created 2,000 years ago is testament to the genius of their creators and to the right of Celtic art to be counted among the world's greatest artistic traditions.

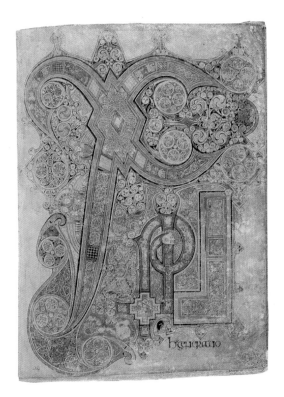

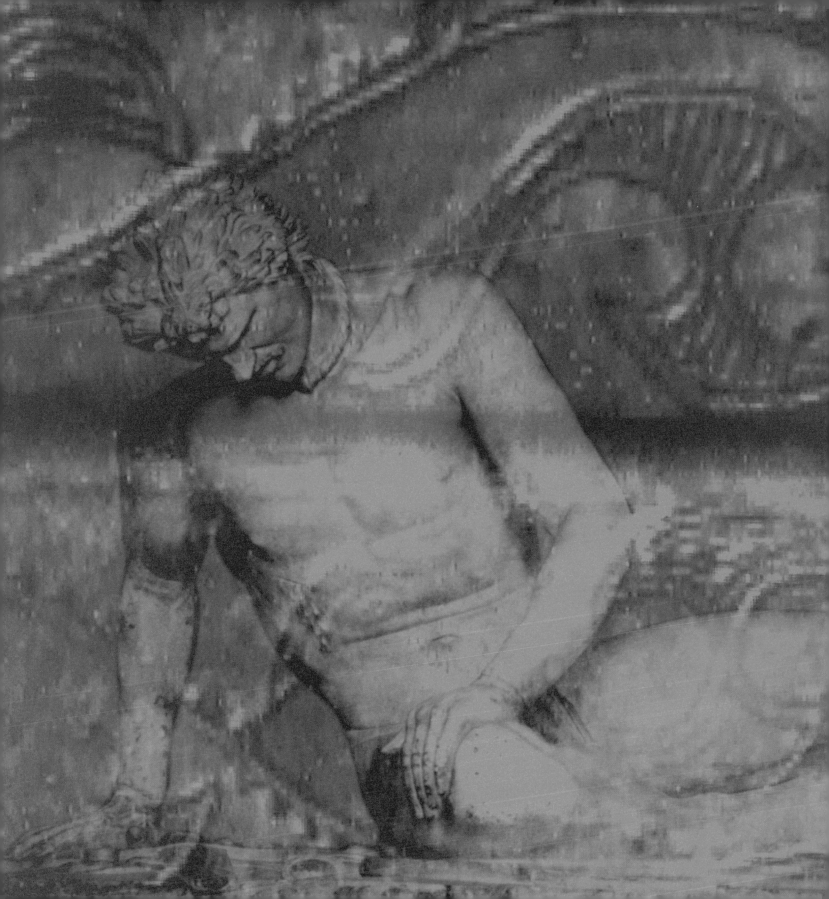

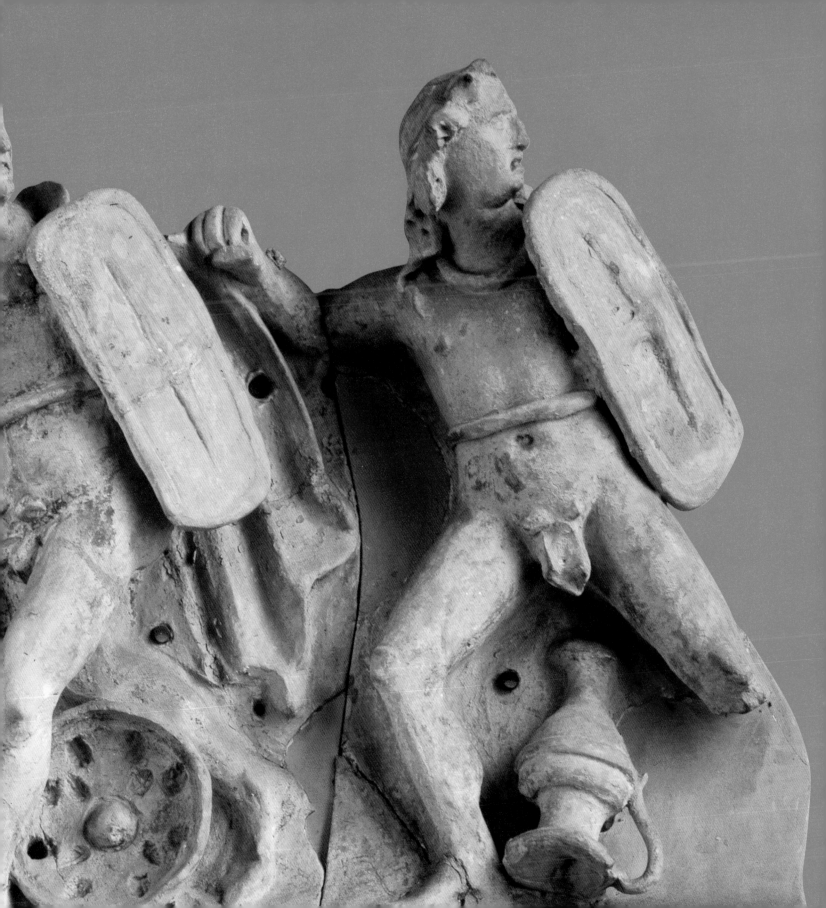

Societies do not simply come into being. They are mainly forged in the

white heat of battle—perhaps over a plot of land or piece of property, to

settle arguments, create new alliances, or to break old ones. This is true on

both local as well as international levels. When one considers just how

comprehensively the Celts overran and controlled so much of Europe from

the 5th century B.C., it is easy to understand the respect (albeit grudging)

accorded their armies by Greek and Roman historical commentators.

◄ **Roman temple frieze**
(detail), depicting Gallic
warriors fleeing the
Roman army. Italy,
2nd century B.C.

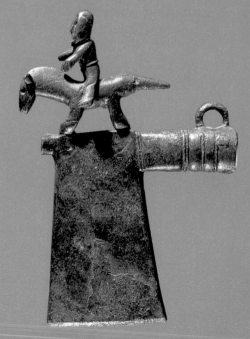

► **Bronze axe** with rider
figure from the Hallstatt
period (7th century B.C.)
from Hallstatt in Austria.

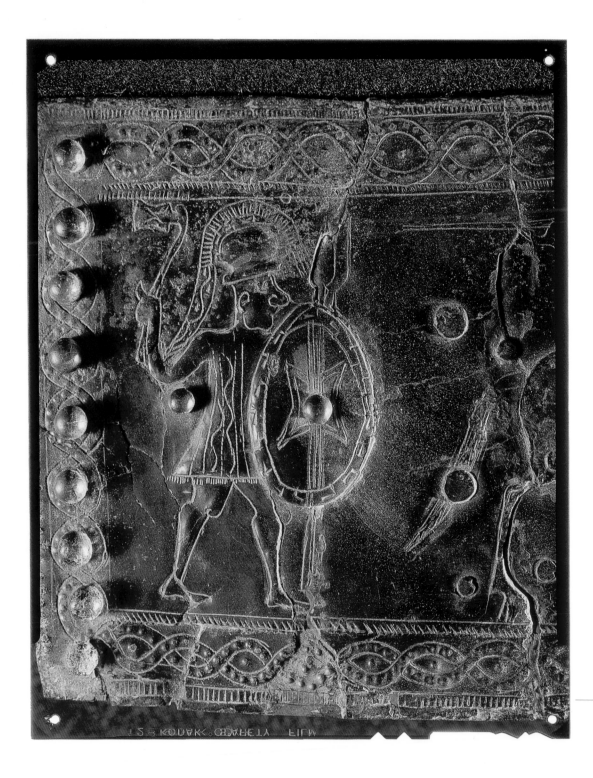

Both of their nations had every reason to be respectful of the warriors they often dismissed as barbarians, especially after Rome and the Greek city of Delphi were sacked by Celts, in 387 and 329 B.C. respectively. It would be almost 160 years before the Romans were able to avenge the looting of their capital with victory in the battle of Telamon, in northern Italy, and a further 100 long and frustrating years would pass before Roman forces actually succeeded in conquering a Celtic homeland, when they finally seized southern Gaul in 124 B.C.

The Celtic fighters' reputation as fearless, and even reckless warriors was based initially on their early ability to use the new-found properties of iron—malleability and strength—to create swords and metal spearheads for the first time. This gave them an undoubted advantage in many of the battles that raged across the fledgling continent for close to a thousand years.

As the classical and Celtic worlds began to deal with each other in a more civilized fashion, by opening trade routes and exchanging goods and services, their well-founded reputation as superb fighters led foreign monarchs to seek out Celts as mercenaries. We know, for instance, that Celtic soldiers formed the nucleus of Cleopatra's personal bodyguard in Alexandria, while Celtic horsemen—famed for their riding skills and fearless courage—were recruited into the Roman cavalry during Julius Caesar's time.

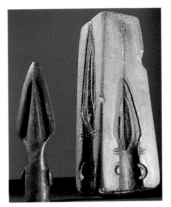

▲▼ **Spearheads** were often of iron embellished with bronze leaf (below), or purely bronze (above, with a mold).

A battle scene on a rectangular bronze belt fragment from the 5th century B.C., found at Vace in Slovenia.

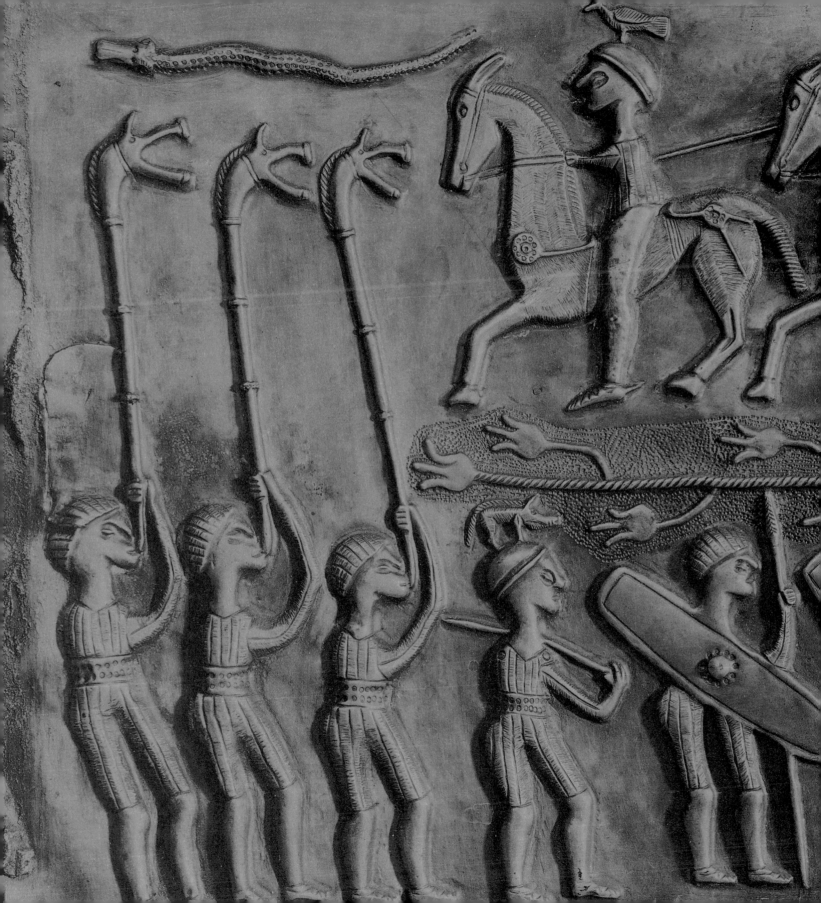

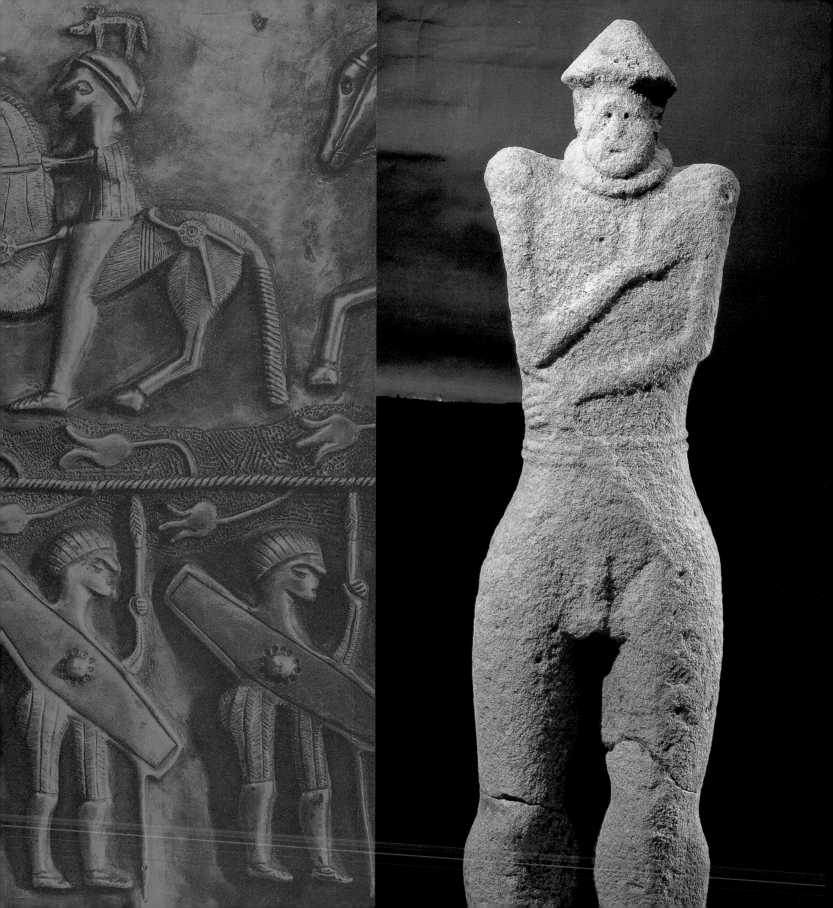

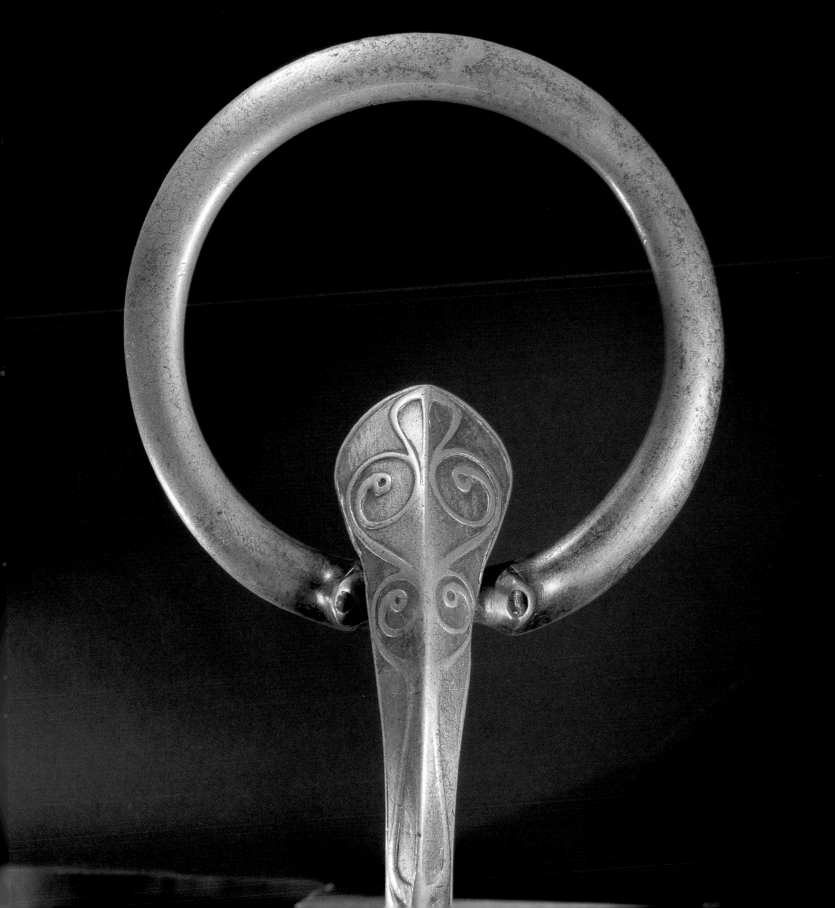

◄ **Previous page:** Left, a panel from the Gundestrup cauldron showing horsemen and foot soldiers. Right, the Warrior of Hirschlanden, 6th century B.C.

◄ **Bronze bit** (detail), part of a 1st century B.C. chariot harness found in a peat bog in County Galway, Ireland.

▲ **Bronze harness plaque,** from the 5th century B.C.

▼ **Enameled bronze** horse's armor plate, 1st century B.C.

It is understandable, then, that Celtic warrior knights enjoyed a social standing surpassed only by tribal chiefs and kings. An aristocratic elite who owned land and rode on horseback, it was they who led armies into battle and protected their overlord when fighting commenced. It is also easy to see how warfare itself became so associated with prestige and display, even a flamboyance which was intended to impress and frighten the opposition in the moments before opposing armies pitched into the fray.

We know that the Celtic foot-soldier sometimes went into battle naked, perhaps the greatest insult of all to his foe. He did not go completely unprotected, of course—shields and helmets offered vital defense, while the range of weapons he bore included spears, swords, and daggers. While some examples of chain-mail body armor have been discovered, these are rare and confined exclusively to late Iron Age sites.

As ever, most of the archaeological evidence has come to us from graves. And while the later Celtic societies (from Hallstatt C onward) buried warriors with their full panoply of weapons and armor, only a few token items were included in the earlier cremation sites.

It appears that weapons buried in tombs, or thrown as votive offerings into water (as legend tells us that Belvedere did with the magical sword Excalibur when the Celtic King Arthur died), were often deliberately broken into pieces or bent out of shape. It is unclear whether this was done to render them worthless, or to transfer them symbolically from this life to the spirit world, their work on Earth having been done.

Celtic arms and battle equipment were usually fashioned in iron or bronze, but the quality of their decoration reinforces the importance of display and outward signs of rank and prestige

The Celts went into battle naked, showing their enemies that they had no fear. Below, a later Roman copy of a 3rd century B.C. Greek bronze known as "The Dying Gaul."

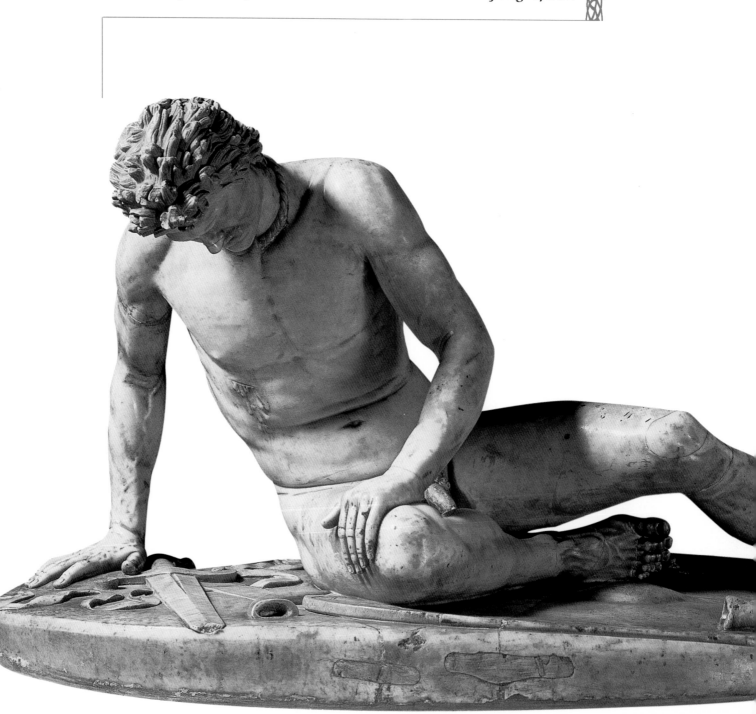

to the Celts. Gold, precious and semi-precious stones, enamels, ivory, and amber were only some of the materials used to enhance helmets, which also featured elaborate carvings or repoussé designs—meaning they were hammered into relief from the inside.

Such items obviously gave Celtic craftsmen the opportunity to express themselves fully as they helped confirm the status of the warrior knight who would wear them. This artistic expression also extended, as we shall see, to other elements, including equestrian equipment.

Swords, the hard sharp blades of which are a triumph of technical skill, were usually long and so were obviously designed as a slashing weapon rather than a close-quarters thrust-and-parrying tool. Although their blades were invariably left relatively plain, hilts and scabbards offered ample scope for decorative work. And while early scabbards featured simple embellishments, later examples (often formed by overlocking two bronze plates) were much more ornate.

Sword hilts were sometimes fashioned to include a male figure, though we do not know whether they were meant as representations of the owner, or of gods.

Scabbard decorations present a great variety of patterns and motifs, some of them abstract but others representational. The animals that appear as ornamental motifs include the so-called "dragon-pairs" which began to appear on scabbards

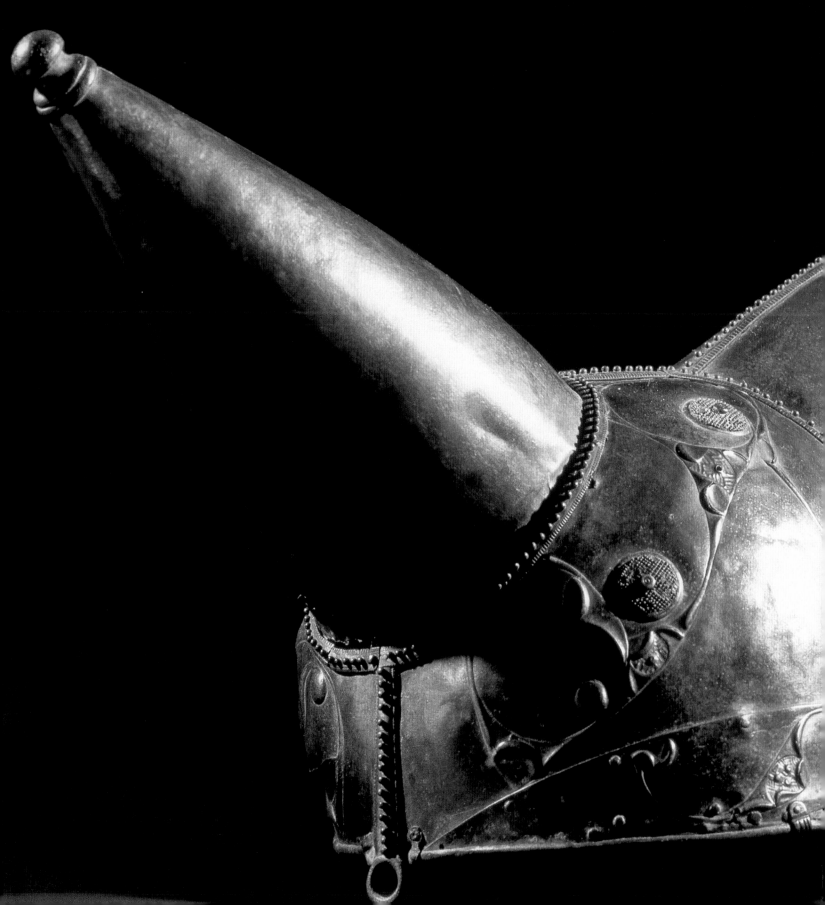

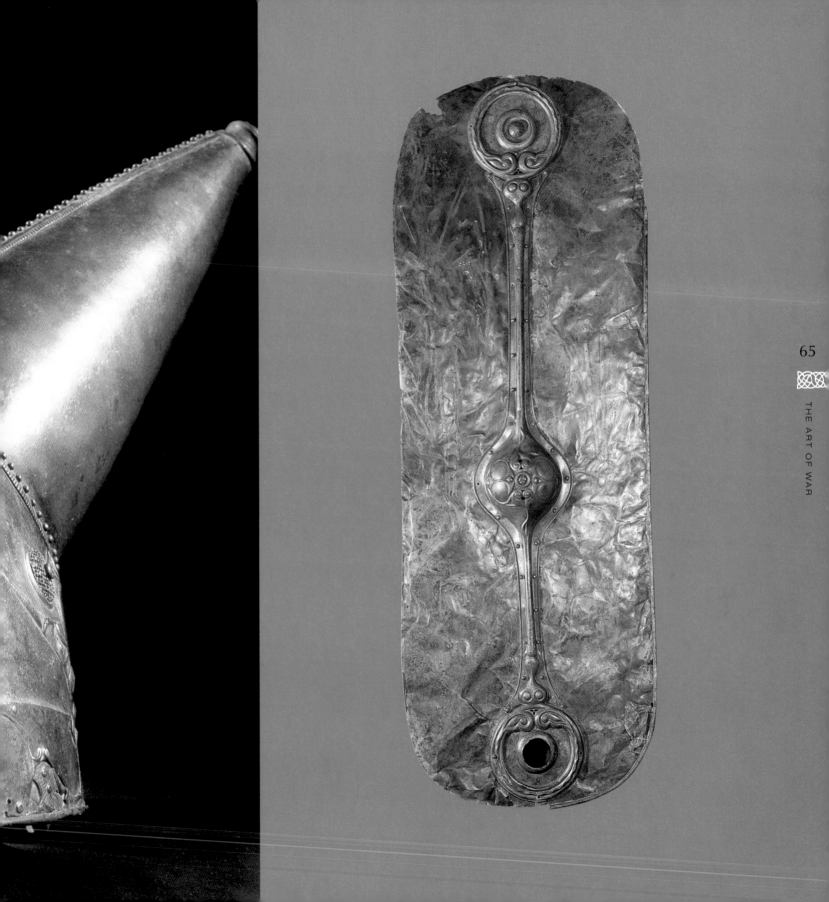

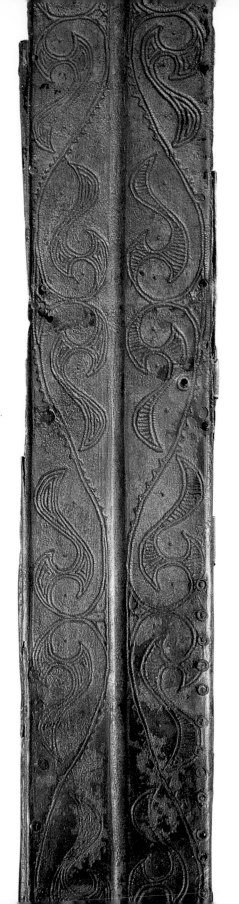

during the 3rd century B.C. As examples of these open-jawed reptilian creatures have been found in southern England, eastern France, Romania, and Hungary (where they may have originated, as the earliest have been found there), and are remarkably similar in execution and design, some believe they may have been created in the same workshop. Other creatures—birds, bulls, and deer included—all held symbolic importance to the Celts and feature in scabbard decorations.

Although war trumpets cannot be described as weapons (unless the din they made qualifies as a form of psychological warfare), they appear to have been used extensively on the battlefields of Celtic Europe. Long tubes of bronze, they ended in a sound-bell which was shaped—most commonly—in the form of a ferocious snarling boar's head, although wolf designs were also quite common. Some trumpets with articulated jaws have also been found.

Body armor, as we have seen, was extremely rare, so apart from their shields, Celtic soldiers had only their helmets to protect them in battle. As you would expect, great care was therefore taken when making these vitally important items, most of which were fashioned in leather, iron, or bronze. Rounded and pointed examples have been found, as have ones with elaborate ear and cheek protectors and, in some cases, a neck guard.

Needless to say, there have been finds which confirm the description of Celtic helmets by the Roman historian Diodorus Siculus who reported that some possessed "projecting figures lending the appearance of enormous stature to the wearer." Most notable of these is a Romanian iron helmet (from the 3rd or 2nd century B.C.) which was topped by a bronze raven with articulated wings and red enamel eyes, while a

◄ **Previous page:** Left,
bronze helmet found in
the River Thames. Right,
3rd century B.C. shield
found in Witham, UK.

◄ **Bronze sword scabbard**,
detail showing engraved
decoration. From County
Antrim, Ireland, 2nd
century B.C.

▼ **Detail of the peak** of a
bronze helmet from the
Ist century B.C., found in
London in the River
Thames.

1st century B.C. helmet found in the River Thames, near London's Waterloo Bridge, featured twin horns—a twin symbol representing virility and ferocity to the Celts.

Only British shields—and they were from the Bronze Age—appear to have been been faced with metal. For the main part, Celtic warriors used leather or wood constructions whose only metal part would be the boss, positioned at the center of the shield and anchoring the handle on the reverse. Only this boss was decorated, the rest of the shield's long and mostly oval form remaining unadorned.

However, the four major British shields—three found in Thames River mud in the heart of London, the fourth in Witham, Lincolnshire—may disqualify themselves as genuine articles of war as their decorated bronze coverings (which is all

that survives) are thought too flimsy to have offered any real protection. That said, they are nevertheless unique in the Celtic world and feature a wealth of relief and repoussé work, inlays, and emblematic symbols including the ubiquitous treskeles, swastikas and, more unusually, ying-yang motifs.

It was some time in the early Hallstatt Iron Age that a horse-riding aristocracy first emerged, and by the 5th–4th centuries B.C. warriors were including light, two-wheeled chariots among their funeral possessions. Interestingly, while it is clear that Gallic Celts had all but abandoned chariot warfare by the mid-1st century B.C., the British army led by Cassivelaunus which confronted Julius Caesar during his second triumphant

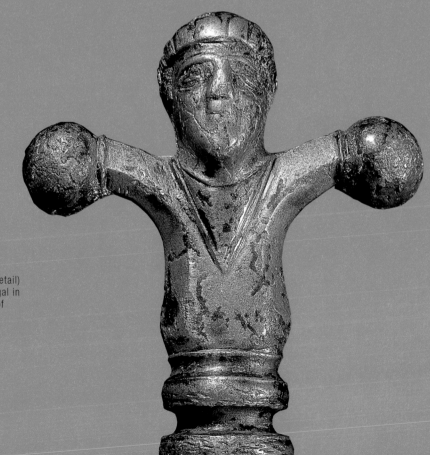

▶ **Bronze sword hilt** (detail) found in County Donegal in Ireland, but probably of French origin from the 1st century B.C.

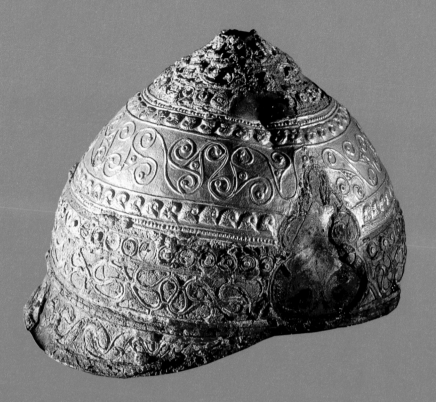

◀ **Bronze helmet** from the 4th century B.C., decorated with intricate patterns in iron and gold plating. Found in France.

invasion in 54 B.C. was said to be centered on a force of more than 4,000 chariots. Chariots remained a key military element in Britain for another two hundred years or more, while they continued in use in Ireland for seven hundred years after that.

We know that the chariot was a considerable status symbol in Celtic society, and this was especially true of high-ranking females. While we know that some women were warriors—the British queen Boudicca being one notable example—it is more likely that a chariot was the ultimate status symbol for a Celtic noblewoman, who would undoubtedly have insisted that its decoration and finish were second to none.

Metal fittings—especially lynch-pins and mounts—inevitably bore images of humans or animals, including bulls, horses, and owls, while horse-bits, rein-rings, and harness ornaments often carried enameled designs of great intricacy and complexity.

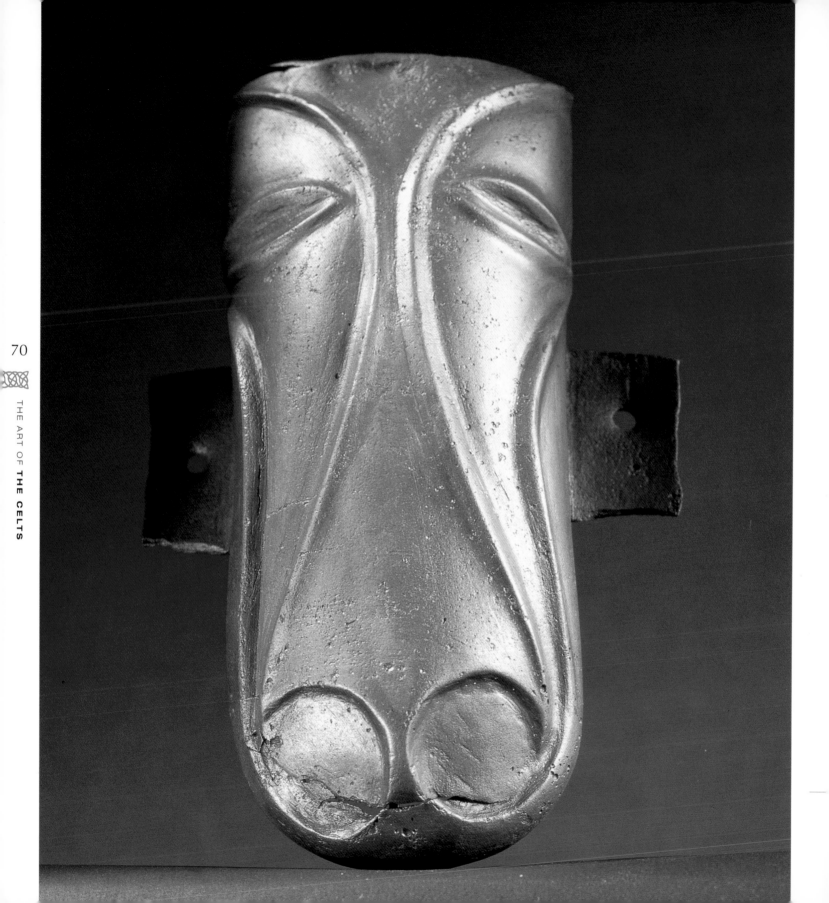

The horses themselves did not go naked into the Celtic battlefield, some apparently having their own ornamental regalia to match anything that was worn by their riders or drivers. The single most outstanding find of this type in Britain is the bronze, two-horned pony-cap (or chamfrein) which was unearthed from a peat bog at Torrs in the Scottish county of Dumfries and Galloway.

Boasting two eye-holes and a perforation which may have once housed a plume, the helmet (which shows signs of repair, indicating its authenticity as a "working" article of war) was made from two sheets of bronze and decorated with symmetrical repoussé designs, among which are a minute human face and bird-head motifs, while its horns were each tipped with a bird's head.

War is a serious business. Art is a serious business also, so there is no need to cast around too long for an explanation as to why the Celts lavished as much of their artistic skills on arms, armaments, and other battle paraphernalia as they did on other aspects of their lives.

No effort would be spared in the attempt to project the prestige and honor due to those who helped establish the Celts as one of the ancient world's most formidable and successful fighting machines, just as no short cuts could be taken to ensure that they went into battle bearing the very finest and most potent talismans—for protection, for good luck, for potent virility, and courage.

A chased bronze fitting representing a horse's head, from a 1st century A.D. war chariot found in Yorkshire, UK.

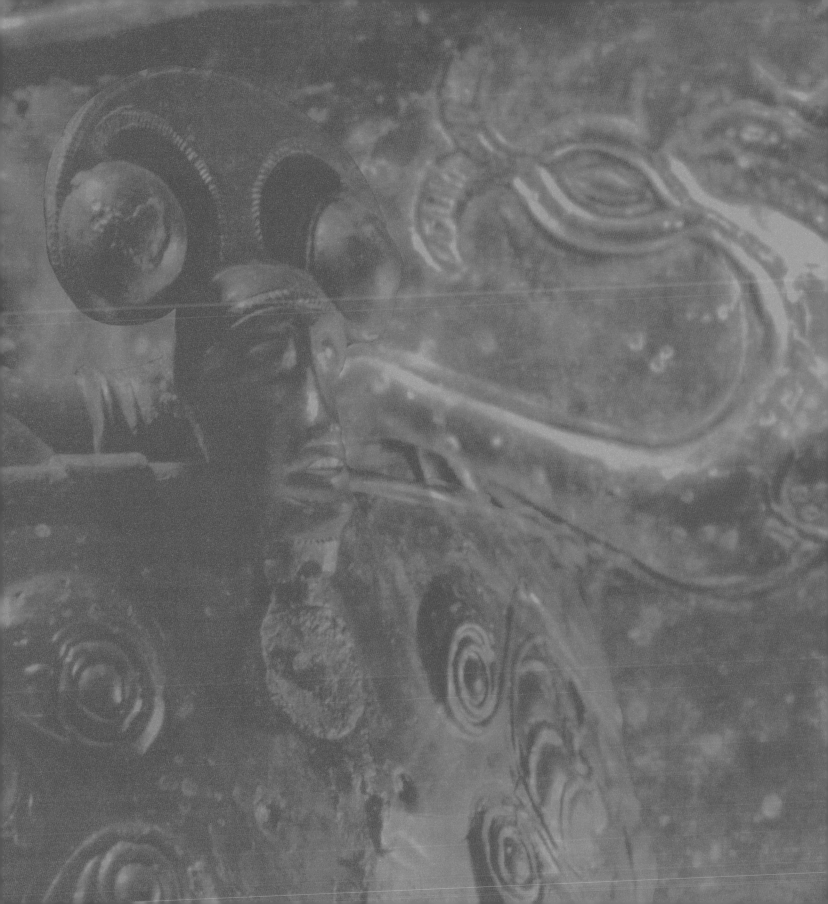

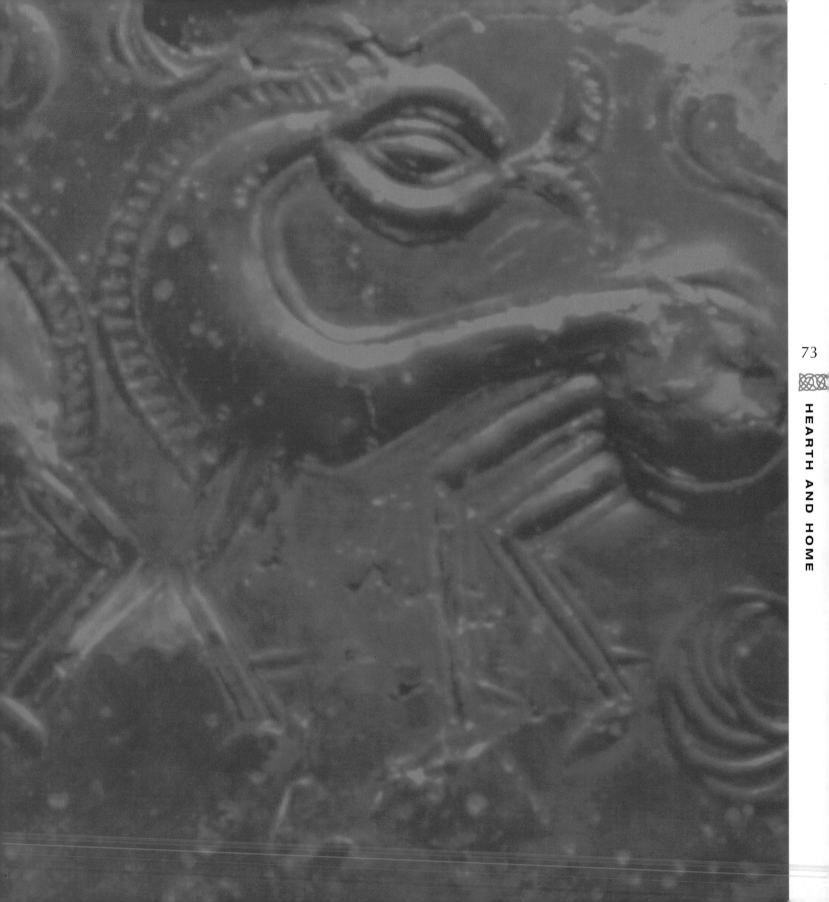

73

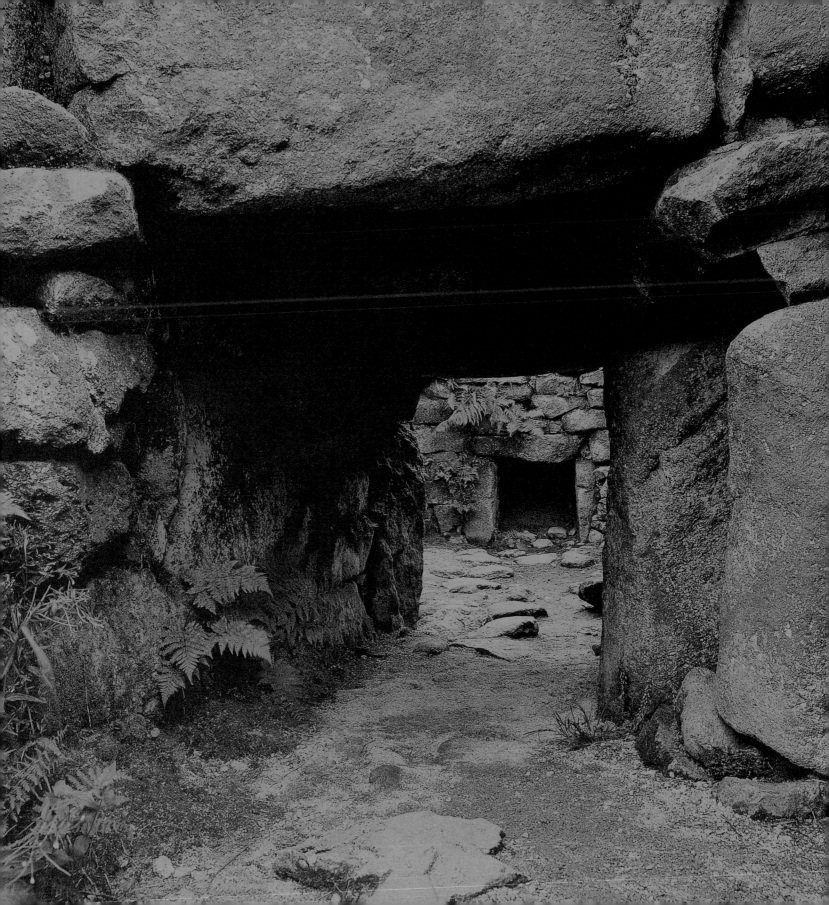

Discovering what we can about the everyday lives of the Celts is

necessarily difficult, for all the reasons stated elsewhere. This is also true

regarding much hard archaeological evidence. To a great extent the Celts

fashioned their homes and other community buildings—storage barns,

meeting houses and so forth—with natural materials such as wood, grass,

and earth, none of which survived the ravages of time and climate for long.

▶ **A fired-clay** Celtic vessel
unearthed at Thuisy in
Marne, France, and dating
from the 1st century B.C.

◀ **An underground
chamber** on an Iron Age
site at Carn Euny,
Cornwall UK, probably a
hiding or storage place.

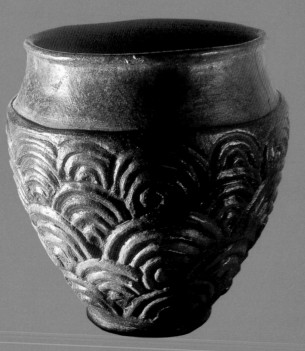

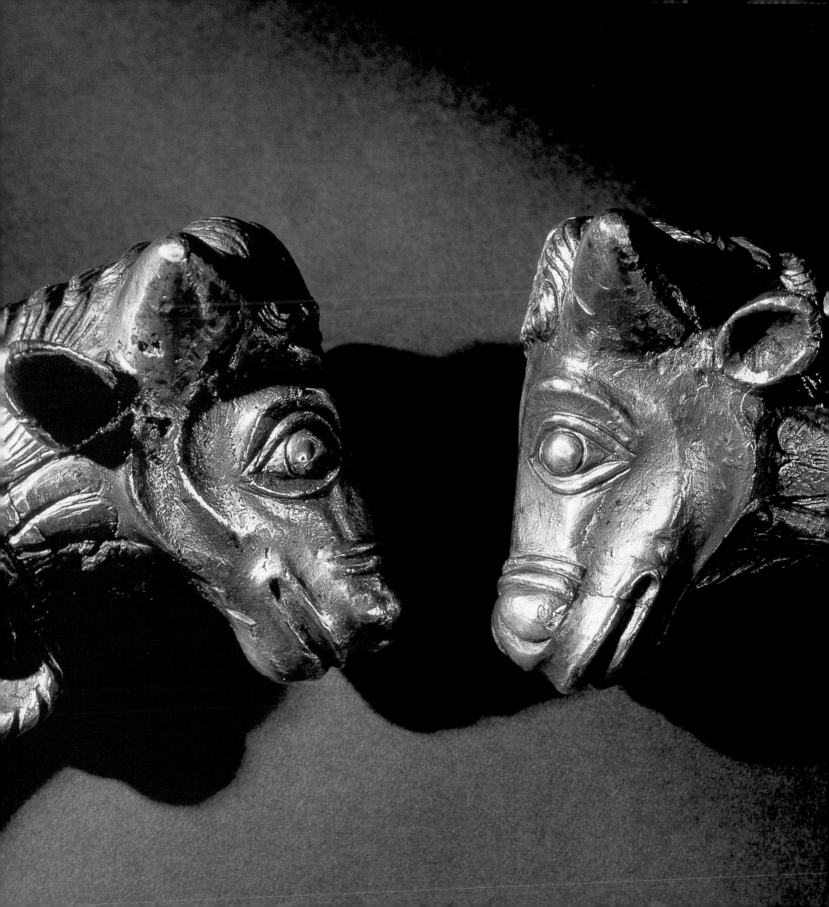

This was even true of their forts, most of which were simply natural features of the landscape—hills especially—around and into which ditches were dug to slow down the enemy, and then the final line of defense which were usually high banks topped with wooden palisades. When—after the Celts were conquered and subjugated by the Roman empire—they finally began to build in brick and stone, those structures were also bound to crumble and decay, their fabric cannibalized by later generations for their own uses.

While the fragments that remain do help throw some light on certain aspects of Celtic society, we again have to rely mainly on the understandably sketchy notes of some of the near-contemporary classical writers (who were inevitably biased and invariably dismissive of their defeated foes) or the accounts left us by Christian monks who, in Ireland at least, did not "Christianize" the legends and myths, preferring to retain many pagan elements.

As ever, these deal very little with the everyday and mundane aspects of Celtic society, and certainly not with the daily round which was the lot of the lower orders. Most Roman accounts concentrate on continental Celts rather than the British and never the Irish (for obvious reasons) while the Irish sagas are devoted

► **Celtic jewelry:** a silver torque with cow heads (see detail opposite) from between the 6th and 1st centuries B.C.

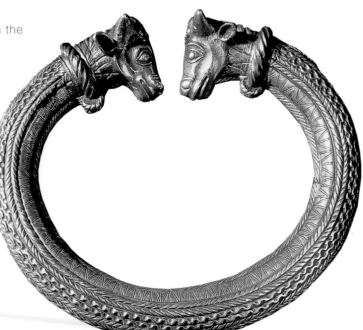

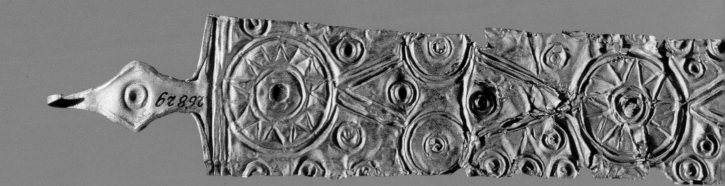

▲ **An engraved gold** belt
and hook from the early
Hallstatt period (8th–5th
century B.C.), found in a
tomb at Hallstatt.

almost entirely to the feats of kings, chiefs, and hero warriors.
Although inconvenient for historians, it nevertheless reinforces
the belief that such champions were considered the most
important people in society.

Assuming that continental and British Celtic societies were
almost identical in structure, classical accounts—combined
with the notes Julius Caesar made during his campaigns—tell
us that Celtic society was essentially tribal, with family units at
its core. According to Caesar, with their complex hierarchy of
kings and chiefs (a sure recipe for disruption, disagreement,
dispute, rivalry, and conflict), the Celts were stratified into three
social orders: druids, equites, and plebes, terms which are
translated as "learned men," "nobles" or "warriors," and
"ordinary people." The warrior class included an elite of heroes.

From Irish sources we understand that the family unit
comprised a *derbfine*, the definition of which appears to be a
group made up of four generations descended from a common
great-grandfather. They owned and worked land collectively,
while succession took place within it. Thus, only a member of
a chief's *derbfine* could succeed him. Each *derbfine* combined
with others to create a tribe (*tuath* in Irish Celtic).

Although the functions of kings and heroes were distinct
and separate, they did overlap at times. Kings, it seems,
mostly went to war only to pursue tribal objectives while

warriors went into battle to wage solo campaigns, or as the king's champion. Nobles were warriors who owed various obligations to the king or chief while the ordinary freemen were mostly farmers who paid food-rent to the king and were given cattle by nobles in payment for various duties.

The druid caste described by Caesar (and referred to in Irish literature as *aes dana,* "the men of art") appears to have been more or less equal in status to the nobility. And while popular misconception has it that druids were responsible only for priestly duties, there is ample evidence that the term also described those whose roles included that of bard, legal arbiter or judge, doctor, musician, and master craftsman.

Members of Celtic communities would have needed both to display their tribal and family affiliations to outsiders and to create some form of recognition to establish or reinforce a person's status at a glance, badges of rank, if you will. And nothing indicates status and wealth better than jewelry and insignia, the more expensive and elaborate the better.

This is confirmed by, among others, Roman historian Strabo who states in his *Geographia*: "To the frankness and high-spiritedness of their temperament must be added . . . childish boastfulness and love of decoration. They wear ornaments of gold, torques on their necks, and bracelets . . . while people of high rank wear dyed garments sprinkled with gold. It is this vanity which makes them unbearable in victory."

There is no accident in Strabo's listing of torques, neck collars, often with elaborate terminals, first in his list of personal ornamentations, for the torque appears to be the single most common adornment worn by Celts of every class. Indeed, a torque was sometimes the only item worn by other-wise-naked foot soldiers, so it may be that it served both as

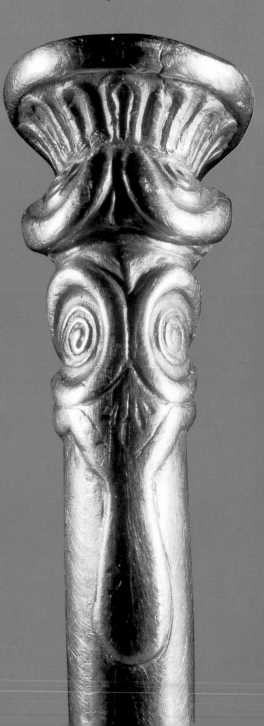

▼ **A solid gold torque** (detail) rich in ornamentation, found in Opluty, Bohemia, and dating from the 4th century B.C.

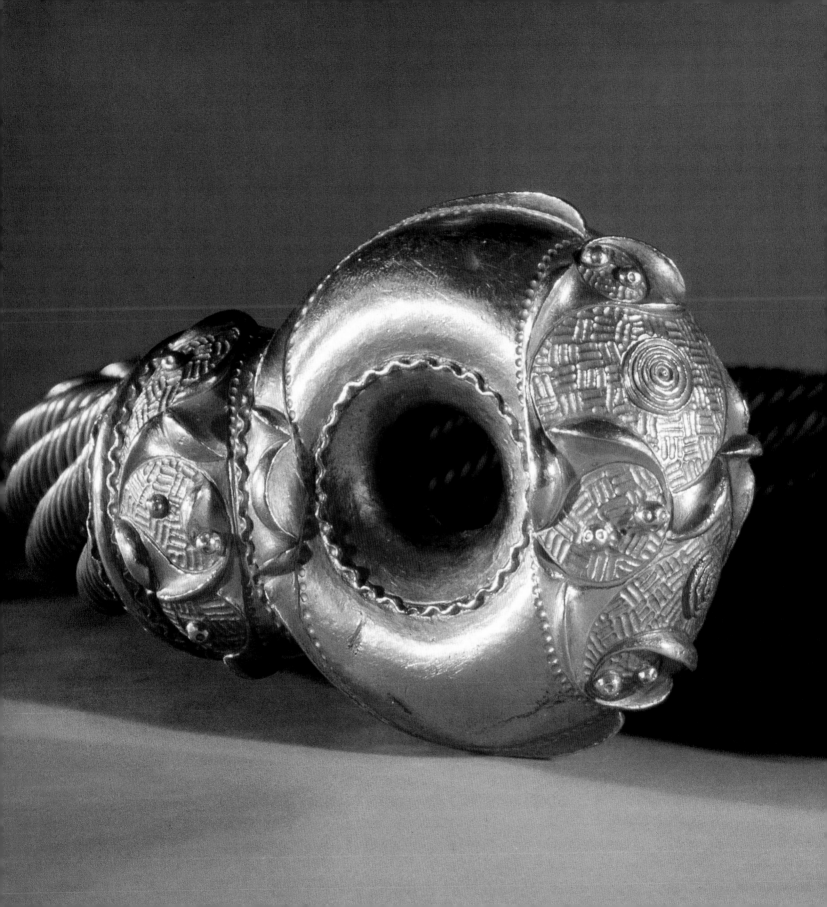

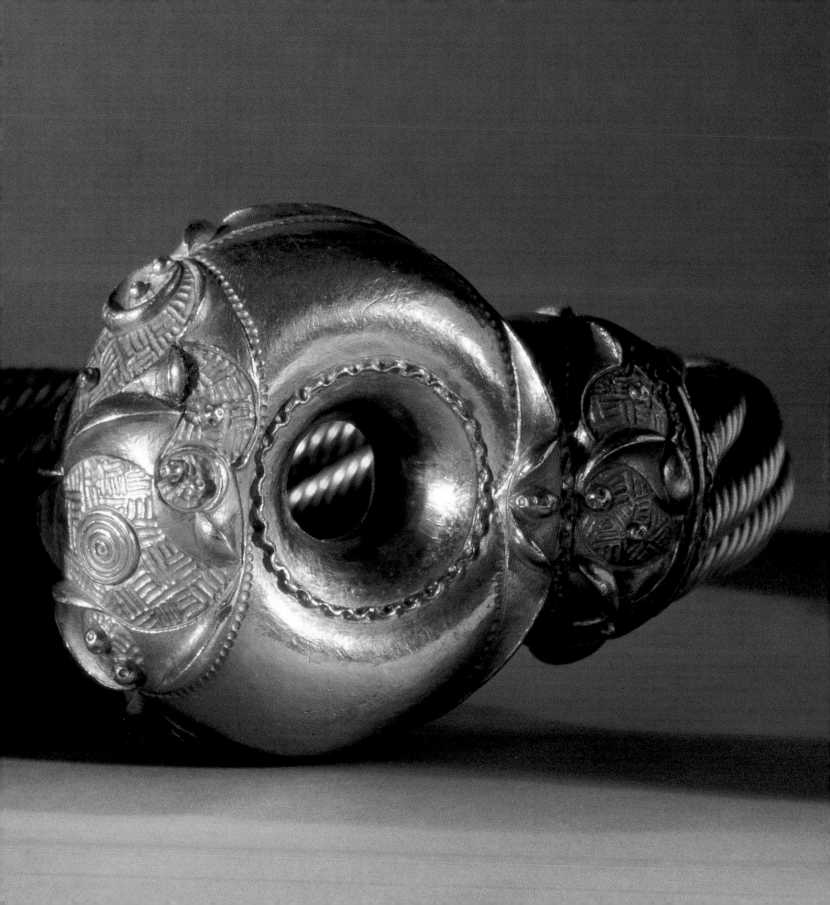

◀ **Previous page**: the Great Torque of Snettisham, the ringed ends decorated in relief. From Snettisham in Norfolk, England, just prior to Julius Caesar's invasion.

talisman and decoration. Obviously, the higher up the social ladder one was placed, the more care, time and skill was dedicated to designing and making one's torque, and also to the metals used.

Gold has always been relatively rare, just as it has always been prized above all metals. It is, however, fairly easy to work (certainly easier than bronze—which demanded copper and relatively rare tin to create—and iron, which was difficult to smelt), did not corrupt too much, and could even be merged with precious stones, ivory, amber, and coral, and produce works of great beauty.

It was for this reason, perhaps, that so many of the torques buried with their owners are of gold, although there are examples fashioned from iron, bronze, silver, and electrum, a gold/silver ally. The most spectacular cache of torques ever discovered was the mass of almost 200 found at Snettisham, Norfolk, which included samples in all those precious metals.

Some of the regal torques found in graves are exquisite, many of them including a wealth of decoration which was the

◀ **Gold fibula** (top) and button, from the tomb of a Celtic prince near Reinheim, Germany.

The bronze "Petrie Crown" finely ornamented with trumpet patterns and crested bird heads, from the 1st century A.D.

result of expert punching, chasing, and piercing. We can only guess at the significance of some symbols and designs wrought into them, but it is not too fanciful to believe that they may have indicated the owner's title or status within a family or tribe, or that they could have been a form of heraldic device.

Irish Celtic society appears to have boasted two specific types of object linked to rank and ceremony—trumpets and crowns. A number of elaborately wrought bronze trumpets have been found in Ireland, the most imposing of which are a set of four that were deposited in a lake at the foot of a hill at Loughnashade, County Armagh, where the huge Navan Fort was located. The site in which they were found also contained human skulls, suggesting that it was the location for ritual activities. The fact that they had been placed in water is consistent with the Celtic practice of offering prestigious gifts to the gods in such fashion.

Among the Irish crowns which have been so far located are two examples of special note—a 1st century A.D. example found in Cork (surviving in the form of three horns with traces

83

HEARTH AND HOME

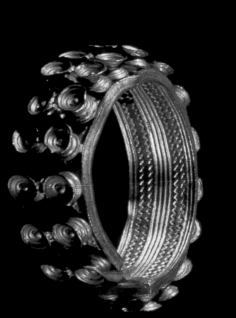
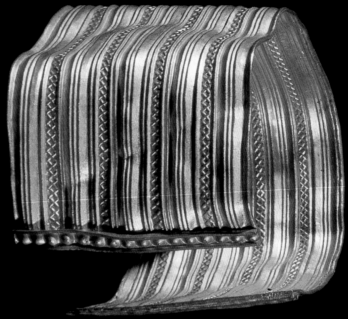
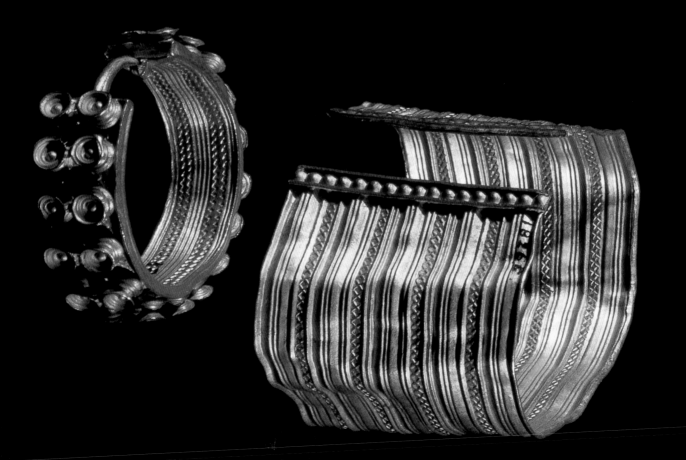

of leather attached to them) and the so-called Petrie Crown, an unprovenanced but more complete item which consisted of a number of hollow bronze horns which were attached to disks mounted on an open-work band. The whole was decorated with delicate repoussé curved lines.

Some crowns found in British sites were adjustable, suggesting that such regalia was either shared or had been passed down through generations. Although the workmanship they display varies from region to region and with changing times, it is always of the very highest quality, as befitted the status of its owners or wearers.

Apart from torques, the most important types of Celtic jewelry are bracelets and anklets, armlets, brooches, ear and finger rings, and belt ornaments. The greatest displays of wealth, in terms of personal jewelry, have been found in European graves of the 6th–4th centuries B.C., after gold acquired its prestige and value for the nobility. From these we know that both men and women wore jewelry.

Armlets appear to have been almost equal in importance to torques, and while most males wore only one to their grave, females invariably wore two—one on each arm. Like torques, armlets were destined to change in fashion through the centuries. By the late Iron Age, for example, Scottish Celts favored huge coiled bronze armlets, some of which were decorated with enamel.

The decoration of torques, armlets, and other jewelry featured many common themes—human and animal motifs abound, as do triskeles and swastikas—but the terminals of torques offered the greatest scope for those final elaborate and often expensive touches, including the inclusion of precious gems and fine filigree work.

◀ **Gold bracelets and earrings** found at the burial mound "La Butte" near Sainte-Colombe, Burgundy, France (c.500 B.C.).

The famous 8th century A.D. "Tara Brooch" of gilt bronze with gold filigree, set with amber and glass mounts.

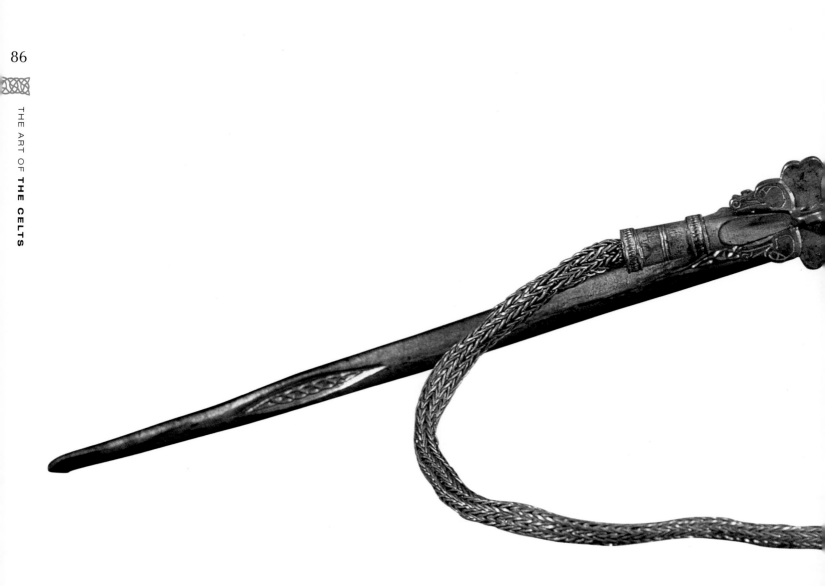

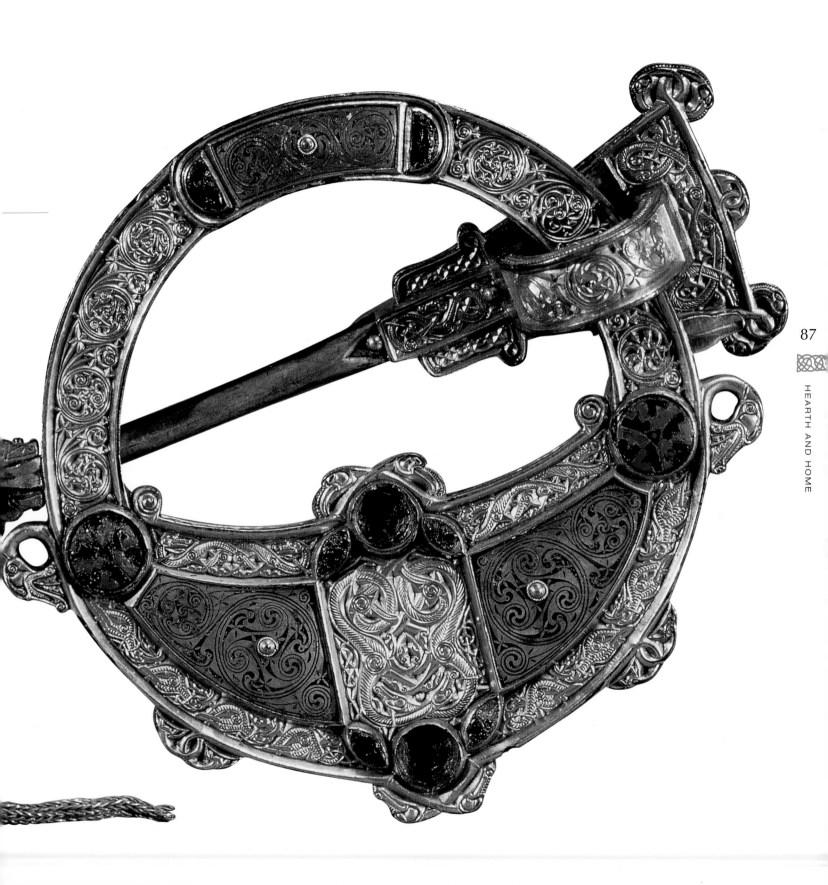

Both men and women wore ear and finger rings, many of them bearing symbolic motifs and elaborate designs, with gold the most popular metal, although silver, bronze, and electrum also frequently appear.

Some quite spectacular brooches, belt plates, buckles, or hooks have been found in Celtic graves, such items again offering ample space for Celtic craftsmen to work their magic with a variety of designs, motifs, and inlays. Indeed, so small are some symbolic motifs, that they again suggest they had personal meanings which only the wearer, and the gods, may have understood.

Brooches especially, provide us with a vast richness of craftsmanship and beauty which is often breathtaking. Their prominence on the wearer's clothing undoubtedly lent them especial importance as status symbols. And, as far as status symbols go, few rival the so-called Tara Brooch, an 8th century A.D. silver-gilt creation from County Meath, Ireland. This 8¹/₂-inch-wide (22.2 cm) masterpiece was fashioned by using a variety of engraving, relief-work, chip carving, and filigree techniques, along with fine gold wire, blue and red enamels, and bands of amber, to create a timeless and match-less triumph of late Celtic craft and design.

Great craft and design were employed in the fashioning of the ceremonial flagons and other feasting paraphernalia found in high-ranking graves, confirming the reputation that the Celts had gained (among classical writers at least) for enjoying a good party and the good life. Writing about the Germans in the 1st century A.D., Tacitus advised his readers that when the Celts were not fighting battles, "they pass much of the time in the chase, and still more in idleness, giving themselves up to sleep and feasting."

▶ **A glass bead** made from a variety of colored glass. Found in Bohemia, from the 5th century B.C.

We know that religious feast days were strictly observed
throughout Celtic society, when the consumption of the best
foods and wines would surely have been a matter of course.
Battle victories would also have given the Celts further
excuses to let their hair down, as would weddings and (one
assumes from the Irish example), wakes. Having fun, therefore,
was a serious business too.

As with their personal adornments, Celtic chiefs and
warriors would want their festival accoutrements to be of the
highest quality. Which is why, from the 6th century B.C.,
graves began not only to include such things as flagons, cups,
buckets, and drinking horns, but provide us with proof that
contact with classical and Mediterranean cultures had become
fairly commonplace.

One of the most impressive of these include a bronze
wine-mixing vessel found in the grave of the princess buried in
Vix, Southern France. From its design, this huge construction
is believed to have been made in separate pieces (either in
Italy or Greece) before being transported to Burgundy,
probably over the Alps.

Among the artifacts placed in the side chamber of a 4th
century B.C. grave found in Klein Aspergle, Germany, were a
host of pottery and metal vessels. These included an Italian
bucket and a two-handled Etruscan stanmos—a tall drinking
vessel—both made of bronze. Other non-Celtic items of note
included a pair of drinking horns which terminated at their
points in rams' heads—a fashion thought to have emanated
in the Black Sea region—and two double-handed cups which
originated from Greece.

It is in items like this—and many others in other graves
across many regions and times from the 6th century B.C.—

that testify most graphically to the steady encroachment of "foreign" influences on the Celts. But even if wine, and the vessels used to transport, store, or drink it, initially came from southern Europe, the demands of local fashion, combined with the natural inventiveness of Celtic craftsmen, ensured that a distinctively Celtic series of designs and decorations would inevitably come into being.

These were often complex and elaborate, the bronze of some examples of flagon being inlaid with polychromatic enamels and other elements, including coral. Wooden buckets were covered in sheet-bronze, and then these surfaces were decorated with characteristic motifs. The same is true of tankards, cups, and wine strainers found in burial sites across a wide range of time and geographical space.

The Celts had much to celebrate. They had conquered and

▶ **The Aylesford Bucket** (from Aylesford,UK) made of bronze and wood, with a detail (left) showing the handle fitting in the shape of a face.

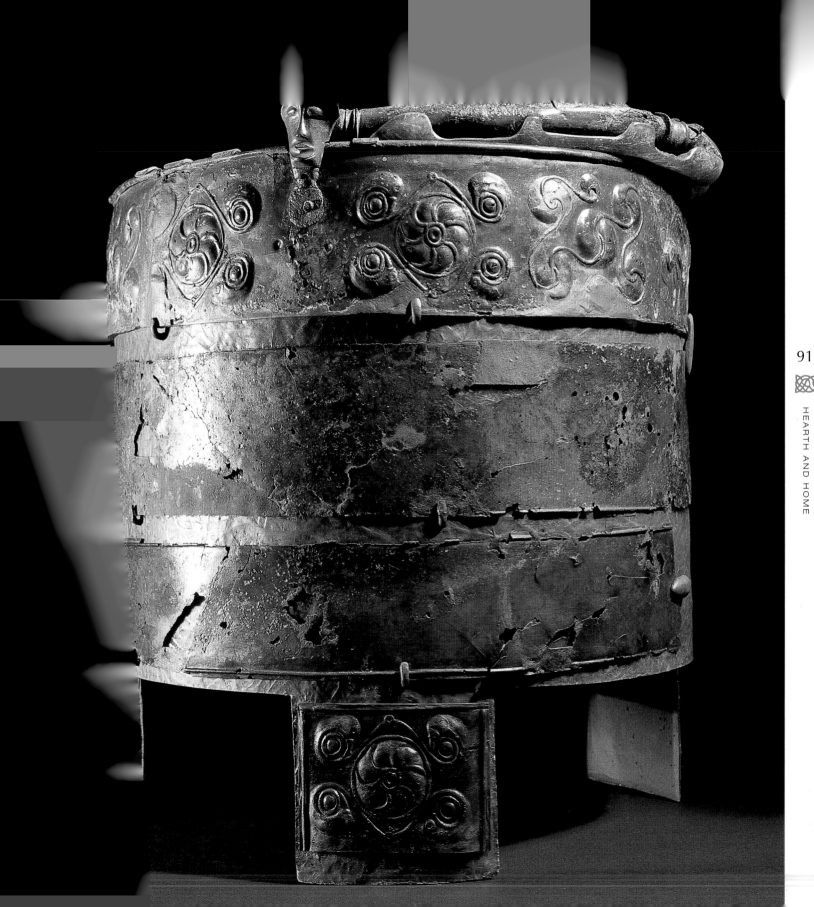

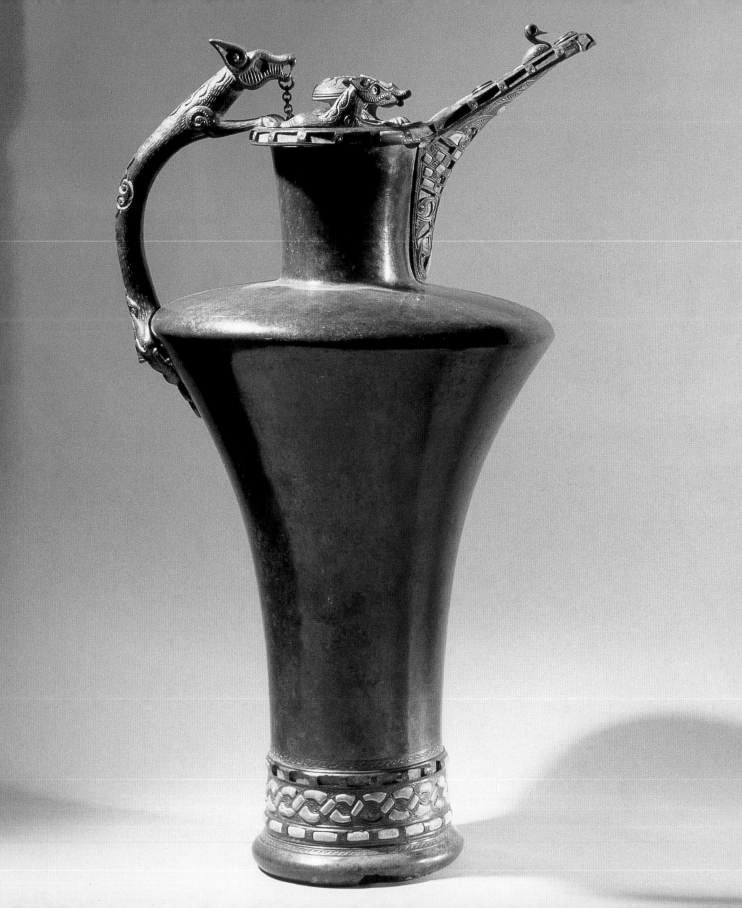

settled a vast sweep of Europe. For many centuries their gods had smiled on them, their armies had been invincible and they had established a more or less unified society in which law and order prevailed. They had perfected many arts and crafts to a high degree, had amassed wealth, power, and influence, and created profitable links with other civilizations, which brought them luxury goods and vital raw materials.

Time and the inevitable and inexorable rise of rival empires would eventually force the Celts into decline and a fall destined to all but obliterate their presence from the lands they once governed. Memories of their presence would prevail in myth and legend, and their great art would one day re-emerge from its burial places, revealing to us the full glory of a people for whom myth was reality and legend was what they created of themselves and for themselves.

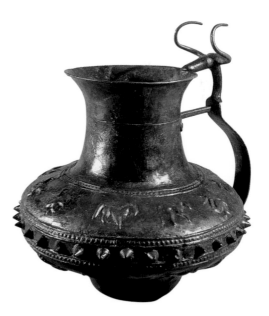

◄ **Banquet jug** inlaid with coral and enamel. The rich ornamentation suggests a religious element and strong Etrusco-Italian influence.

▶ **A bronze jug** from the Hallstatt period, 6th century B.C., with handles shaped in the form of bull's horns.

Historical Events - The Celts	Material Culture	Historical Events - The World
B.C.		
800	Hallstatt Iron Age	Assyrians conquer Palestine and Babylon City of Nineveh built (712) Phoenicians found Carthage
700 Celts invade Britain (c 642)		Assyrians defeat Egypt (c 620) City of Rome founded (c 635)
600		Persia conquers Assyria (512) Nineveh destroyed (528) Greek colony founded at Massalia (modern Marseille) Birth of Buddha (exact date unknown) Birth of Darius the Great, Persian king (550) Birth of Xerxes, Persian king (519) Birth of Chinese philosopher Confucius (c 551)
500	La Tène Iron Age	Egypt, Syria, and Palestine conquered by Persians Foundation of Greek city states (Athens 432, Sparta 431)
400 Celtic Gauls sack Rome (387) Celts sack Delphi, Greece (329)		Persian wars with Greece
300 Romans defeat Celts at Telamon (225)	La Tène tradition in Britain and Ireland	Alexander the Great conquers Egypt, Persia, Greece, and Near East (233-215) Birth of Emperor Shih Huang-ti, creator of first unified Chinese Empire (259)
200 Celtic Gauls attack Rome (136) Romans conquer Narbonensis (South of Gaul) (124)		Romans conquer Etruscans (138)
100 Caesar conquers all Gaul (58-50) and invades Britain (55/54)	Romano-Celtic	Rome defeats Hannibal (37) and conquers Greece and Palestine (39) Rome captures Pannonia (Western Hungary)

	Historical Events - The Celts	Material Culture	Historical Events - The World
A.D.			
0 -100	Claudius invades Britain (43) Britain conquered to Scotland by A.D. 84	Romano-Celtic	Birth of Jesus Christ (15) Cleopatra's Egypt conquered by Rome (20, 38) Destruction of Jerusalem by Romans (70)
100	Hadrian's Wall built (120s)		
200	Gallic Empire (260-274)		
300	Romans withdraw from Britain	Early Christian (Britain and Ireland)	Constantinople becomes Roman capital (330)
400	Saxons invade Britain		Visigoths sack Rome (410) Clovis founds Frankish kingdom (486)
500	St. Patrick brings Christianty to Ireland St. Columba establishes church in Iona, Scotland	Anglo-Saxon (East Britain)	Birth of Prophet Muhammad at Medina (c 570) Magyars conquer and colonize Hungary
600			Byzantine (East Roman) Empire founded (610)
700	Death of Venerable Bede, Anglo- Saxon theologian, historian (735) First Viking attacks on East Britain (789) Vikings invade Ireland (795)		
800	Charlemagne crowned in Rome (800) Scots seize Pictland Work begins at Iona on illumination of *Book of Kells* (late 8th century)	Viking	
900			
1000	Irish defeat Vikings at Clontarf (1014)		Birth of Ssu-ma Kuang, first Chinese historian (1019) Viking explorers discover New World

BIBLIOGRAPHY

Clarke, David and Roberts, Andy (1996), *Twilight of The Celtic Gods,* Blandford, London
Green, Miranda (1996), *Celtic Art,* Everyman Art Library, London
James, Simon and Rigby, Valery (1997), *Britain and The Celtic Iron Age,* British Museum, London
Laing, Lloyd and Jennifer (1995), *Celtic Britain and Ireland, Art and Society,* Herbert Press, London
Luke, Catriona (1996), *Celtic Treasury,* Michael O'Mara Books, London
Rankin, David (1987, 1996), *Celts and The Classical World,* Routledge, London
Stead, Ian (1985, 1996), *Celtic Art,* British Museum, London

THE ART OF **THE CELTS**

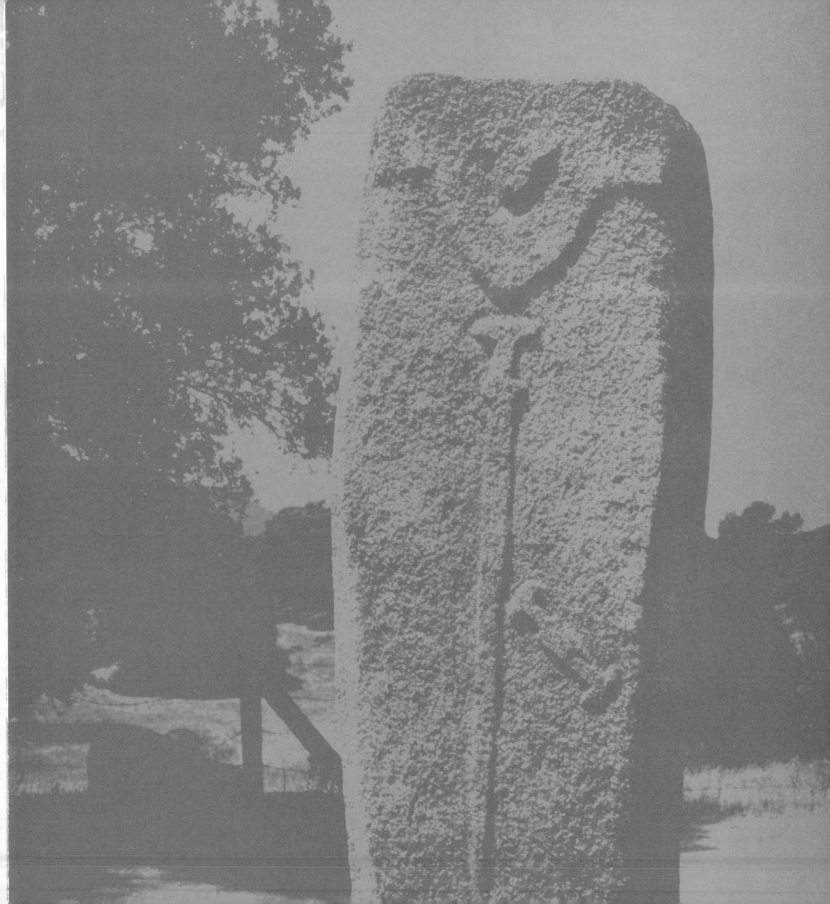